IMAGES
of America

CINCINNATI'S
GOLDEN AGE

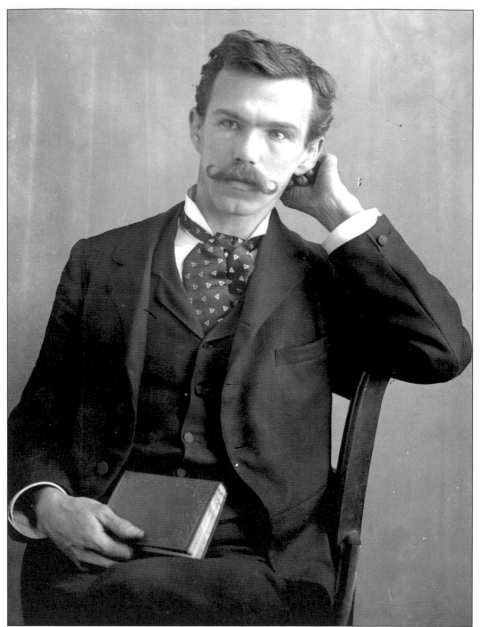

(*above*) Frank Wilmes (1858–1946) was a landscape artist and a jewelry designer. Developed from glass negatives, his photographs are the basis for this book. His home for his adult life was on upper Elm Street in Over-the-Rhine. Using his avocation of photography, he captured scenes that were the basis for his paintings. It is fortunate that he chronicled the daily life of our city at this time and that the negatives weren't destroyed after his death.

(*cover*) This stylish room was the height of artful clutter. Every surface, as well as the walls and furniture, is covered with a profusion of objects reflecting the Victorian shunning of empty space. Still, it reflects homeyness and individual taste. Cincinnati was then a center for furniture manufacturing. Two of the best names were Mitchell & Rammelsburg Furniture Co. and Henshaw & Sons.

IMAGES
of America

CINCINNATI'S
GOLDEN AGE

Betty Ann Smiddy
with the photography of Frank Wilmes

ARCADIA
PUBLISHING

Published by Arcadia Publishing
Charleston SC, Chicago IL, Portsmouth NH, San Francisco CA

Printed in the United States of America

Library of Congress Catalog Card Number: 2005928552

For all general information contact Arcadia Publishing at:
Telephone 843-853-2070
Fax 843-853-0044
E-mail sales@arcadiapublishing.com
For customer service and orders:
Toll-Free 1-888-313-2665

Visit us on the Internet at www.arcadiapublishing.com

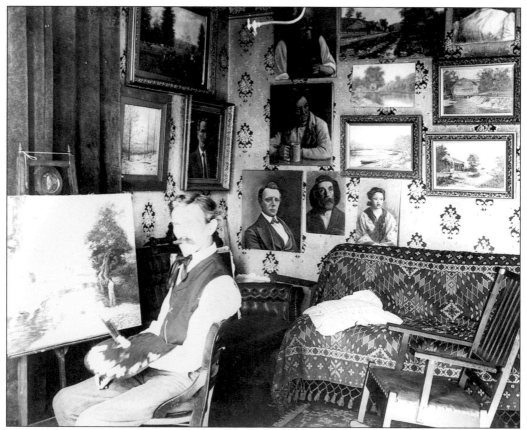

This is the studio of Frank Wilmes with a landscape in progress. Well known as a painting retoucher, the artist stayed with Archbishop McNicholas in Norwood while he restored the archbishop's extensive art collection. His paintings on the wall reflect the various subjects that he used.

CONTENTS

ACKNOWLEDGMENTS

I would like to thank my cousin, Rose Ann Deak, and her children, Joseph and Mary Ann, for giving me permission to put these wonderful photographs into print. My husband, Bruce A. Buckner, was behind this book all the way. Mary Ann Greenwald was my proofer-in-chief. I could always rely upon my friends, Connie, Ricki, Joe, Karen, and Penny for support. Melissa Basilone, my Arcadia editor, was very helpful and enthusiastic; her assistance made this project a joy to create.

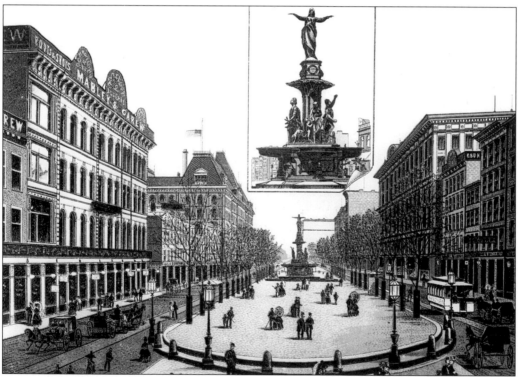

During the time covered in this book, Fountain Square would have looked like this etching. The fountain was facing east, whereas it now faces west. The building to the left with the flag at half mast was the old U.S. Post Office and Courthouse, designed by Samuel Hannaford and completed in 1885 at a cost of five million dollars. The fountain and surrounding plaza were completed in 1871. (William H. Deak Collection.)

INTRODUCTION

While Cincinnati today is an office center rather than a retail destination, a century ago it was filled with stores and manufacturing, its sidewalks crowded with people. Many lived within walking distance of their job. Voices in Italian, German, Hungarian, Irish, and other languages filled the air where people gathered. Some neighborhoods were distinctly ethnic, such as the Irish on Mt. Adams and the Germans in Over-the-Rhine. The city's most renowned buildings were being erected. It was a time of optimism, hard work, and prosperity for many. Cincinnatians were happy—we consumed 46 gallons of beer per every man, woman, and child for the year of 1899.

Frank Wilmes (1856–1946), landscape artist, jewelry designer, and amateur photographer, lived at 1560 Elm Street. He studied at the Cincinnati Art Academy under Frank Duveneck (1848–1919). At the end of his prolific career, Duveneck returned to Covington, Kentucky, from Europe to accept the position of instructor, and later the director, of the Cincinnati Art Academy. There, Wilmes was a promising student and exhibited in the academy's shows in 1895, 1897, 1910, 1914, and 1918. For many years, he was the secretary of the Cincinnati Art Club. Wilmes photographed a series of Duveneck demonstrating portrait painting and relaxing in the company of friends. The Cincinnati Art Museum has the nation's largest collection of Duveneck paintings.

Wilmes was the son of Thomas Wilmes, a fire insurance agent. Thomas and his wife, Mary Elizabeth, were both born in Westphalia, Prussia. Their sons William and Frank started as jewelers, while another brother, August, was a paperhanger. Joseph, Andrew, John, and a sister were the other siblings. Successful as a jewelry designer, Frank was also well known as a landscape painter and painting retoucher. He married, divorced, and had a daughter, Elizabeth. He worked in his later years for Huber Art Co., 123 West Seventh Street, and the Dorst Jewelry Co., Walsh Building, Third and Vine Streets. In 1929, he worked for Archbishop John T. McNicholas retouching his paintings. During this time, he lived there in Norwood as McNicholas's guest.

His photographs were used for postcards and some were published in *Playmates of the Towpath* (1929). Several of his canal photos have been published in other books, but without his name for credit. Up to now, Frank Wilmes has been forgotten as a photographer, while his local pictures are historically significant.

William H. Deak was a man of many talents and numerous hobbies. Rose Ann, his wife of 56 years, had often told him that he had been blessed with such a gift in his hands and his brain to bring forth these talents and skills to create, invent, remodel, build, or repair just about anything. Two of his special interests were photography and his many tools.

He started in photography as a young man of 17 or 18 years old with a small Kodak Brownie camera. He took it upon himself to empty his clothes closet in the bedroom of his parents' home to create his first darkroom—with a paper sack over the light bulb to develop film. From there,

he graduated to an unused pantry and, many years later, to a large room that he transformed into the darkroom he had always yearned for. By that time, he had much better cameras and a professional safelight to work with the over 100-year-old negatives.

How he came into possession of Wilmes's negatives is a story in itself. In 1947, an old family friend revealed to Bill that one of his tenants had recently passed away—a Frank Wilmes, who possessed old books, another of Bill's interests. Wilmes—an artist as well as photographer—also owned glass negatives, and his sister was preparing to dispose of his effects. Bill purchased not only books that day, but also a huge collection of glass negatives; he used some of the rent money to do so.

It was not until the 1980s that the opportunity to do something with the negatives came about. Working with these old glass negatives was quite a challenge and not as simple as working with modern-day films. It took a lot of skill to bring forth an acceptable black and white print. It took many test strips and hours of work to get the correct shading and the right tone. Some negatives were too dark or some areas of them too dim, needing longer or shorter exposure under the enlarger to burn in the images. Bill sometimes used a cardboard paddle cut from the back of a tablet to shade areas of the negatives from the darkroom lamp that needed less exposure than the rest. Sometimes filters were needed in the enlarger and guesses were made as to how many to use. It might take Bill 30–45 minutes of testing before he was satisfied to go ahead and develop a full print. The quality of his work was attested to by the public, who bought prints readily when Rose Ann and Bill displayed them at antique shows.

A great deal of skill was required to work with these old glass negatives, but William H. Deak was the kind of person to supply it. He possessed the gifts of patience and skill to make things work.

Betty Ann Smiddy
Rose Ann Deak

William H. Deak.

One

I Gotta Mule and Her Name Is Sal

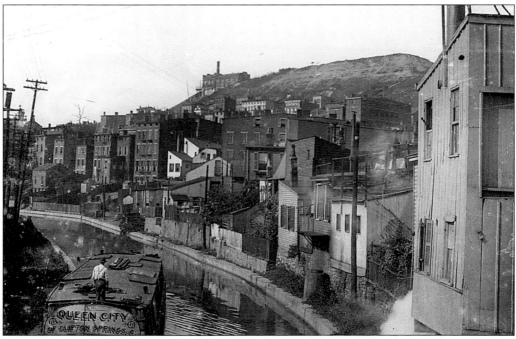

The *Queen City* rounds the Mohawk bend on its return passage to Northside's Clifton Springs Distillery in 1910. A boat would carry 350–450 barrels to a spot behind Music Hall, where workers would unload them. The whiskey would then be hauled to its destination—steamboat, railroad, or neighborhood bar—by horse-drawn wagons. Seen on the hill in the background is the Fairview Incline. Steam in the foreground was emitted from the slaughterhouses and tanneries that backed up to the canal.

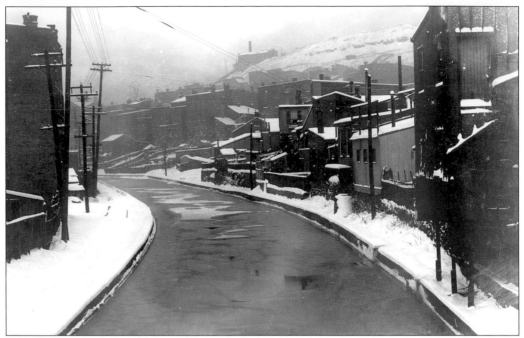

This image shows the scene from the previous page in winter. When the canal iced over, children skated along its length. The canal posed a drowning hazard for the neighborhood children. Over half of the German immigrants settled immediately north of the canal, giving the general area the name of Over-the-Rhine.

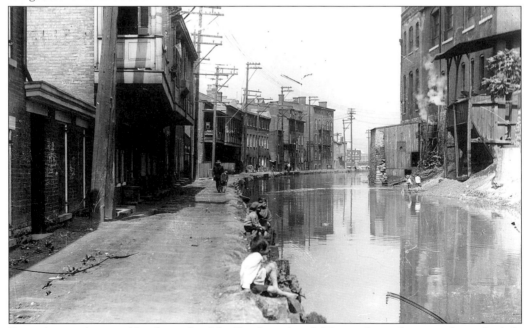

Boys play on the canal bank south of the Brighton bend. Notice the wide towpath on the left, used by mules or horses to pull the boats. Houses backed up to the towpath. When the canal was replaced in the 1920s by the aborted Cincinnati subway, houses this close to the construction sustained damage.

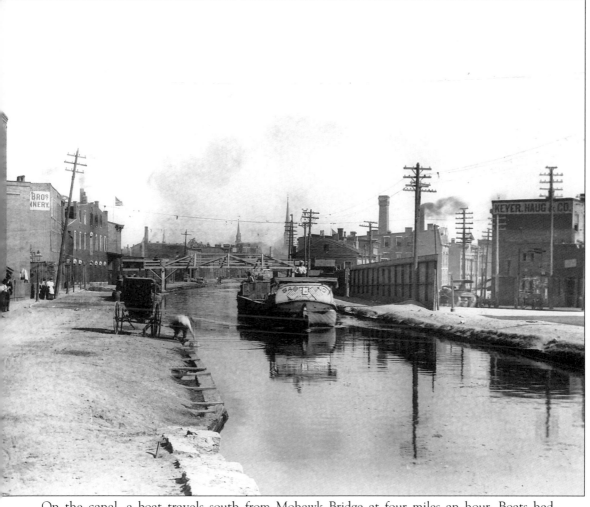

On the canal, a boat travels south from Mohawk Bridge at four miles an hour. Boats had a 10 mile speed limit because the water would wash up and over the berm. They carried lumber, leather goods, soap, meats, whiskey, corn, flour, beer, and just about anything that was manufactured or grown near the canals. Some boats were double walled and insulated, carrying ice packed in sawdust. In the winter, water would be diverted from the canal into flat fields enclosed with three-to-four-foot dirt walls to form ice ponds. Once a pond was frozen, the ice would be cut and stored in warehouses built for that purpose. The largest ice ponds were in West Chester, Fairfield, and Lockland. Smaller ones dotted the canal route. Mr. LeSourd had 10 icehouses and 40 acres of ice ponds, in what is now the location of the lake in the LeSourdsville Lake amusement park. The beer industry used large quantities of ice before the days of reliable refrigeration equipment. The Windisch, Muhlhauser, and Hauck breweries had farms in West Chester where they grew hops and barley, sending it to their breweries via the canal. Visitors can still walk a portion of the route on the Port Union Historic Canal Trail.

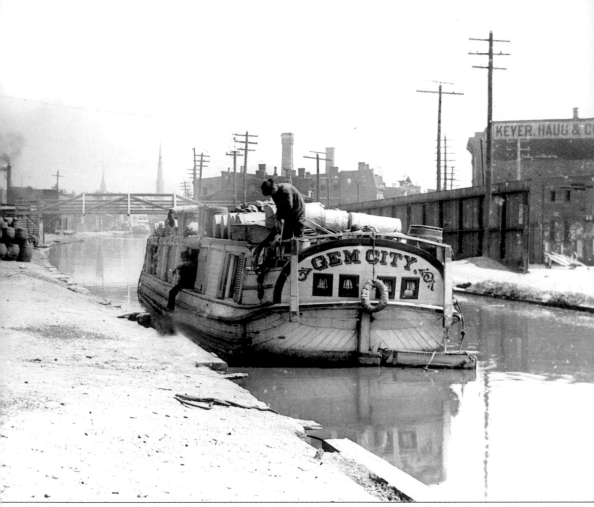

A typical freight canal boat was roughly 85 feet long by 14 feet wide. With only three cabins for the crew, the captain and his family, and mules, only the essentials were carried. The mules would be rotated due to fatigue and had to be included on the boat itself for convenience. Notice the woman, probably the captain's wife, looking from the top deck. This boat was moored on North Plum Street, now Central Parkway.

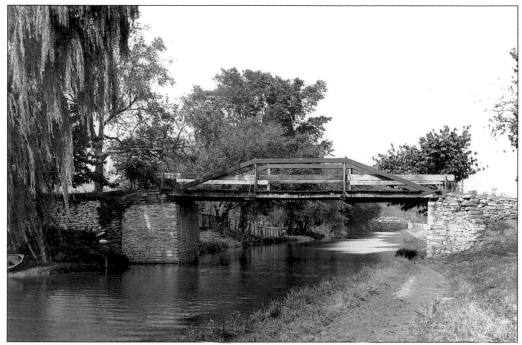

This peaceful canal scene was taken two miles above Lockland. Areas such as this attracted artists and visitors. As long as the canal was used, the flowing water kept it from stagnation.

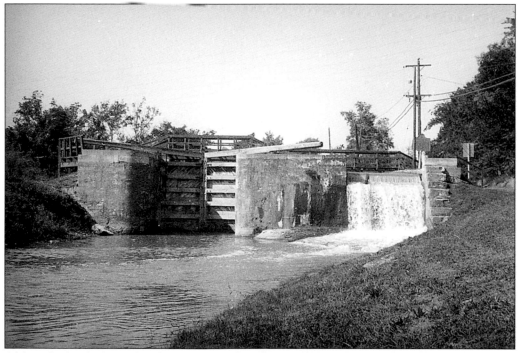

Although the lock is closed for boat traffic, the canal continues to flow from one level to another, as seen on the right. A gatekeeper would be nearby to open the lock and collect a toll fee. Remnants of locks such as this still can be seen in Fairfield and West Chester.

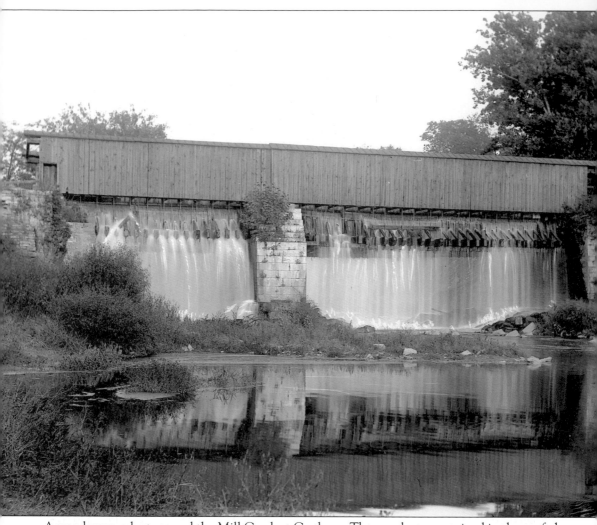

A wooden aqueduct crossed the Mill Creek at Carthage. The canal was contained in the roofed structure. The wooden sides were as high as the depth of the canal, and a towpath allowed the boats to be mule pulled. Swimmers could be washed into the Mill Creek below by the overflow. During the winter, when it froze, it was an impressive sight. The Carthage aqueduct burned, causing local flooding and disrupting canal traffic.

The Brighton Round House was built in 1869 on the slope of McMicken Avenue by Michael Haag for summer concerts. Haag beautified the area and charged a nickel for crossing the canal and using his grounds for picnics. In 1921, it was demolished for new roadwork. Brighton was a busy place with canal traffic, tanneries, slaughterhouses, distilleries, and mills.

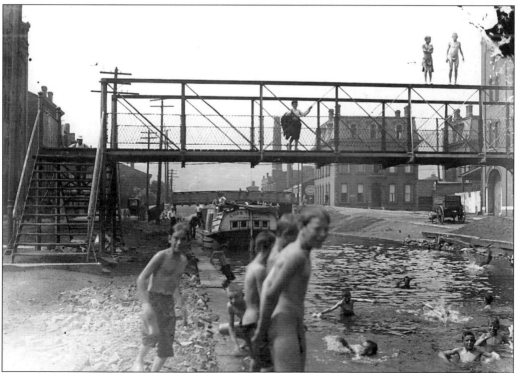

The canal was a popular, although unhealthy, place to swim. These boys at the Wade Street Bridge are having a great time jumping off. "Cheese it! The cops!" would quickly empty the canal of boys, who would return another day.

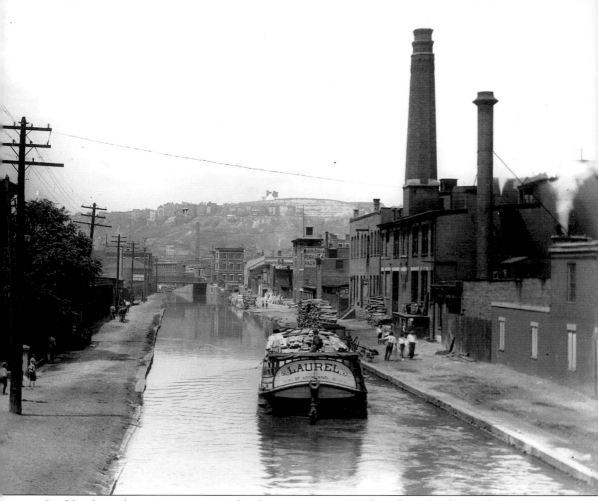

Lockland was home to a variety of industries: cotton, woolen, flour, lumber and paper mills, baking powder, starch, and wagon factories. *The Laurel*, originating from Lockland, carries a load of boards. Lumber is stacked behind the meat packing businesses. This view is looking north from the Liberty Street Bridge. The sign on the end building on the right reads "Foehr & Ziegler Pork & Beef Packers." In the background is the Findlay Street Bridge.

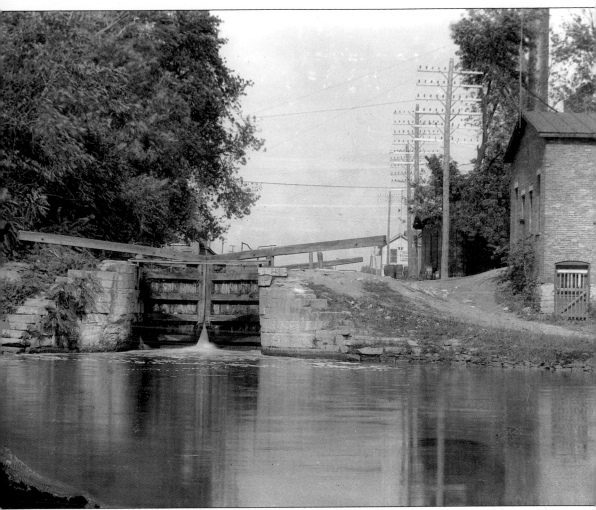

Numerous canal locks gave Lockland its name. A lock was 15 feet wide by 90 feet long, constructed of large stone blocks and buttressed. The two oak gates, here closed, were of heavy timbers hinged to the stone. Two beams extending 12 to 15 feet on either side moved the gates. The lockkeeper and his family lived next to the lock, and someone was always available to open the lock, collect a fee, and change the level of water flowing through the canal. The location is I-75 and Benson Street today.

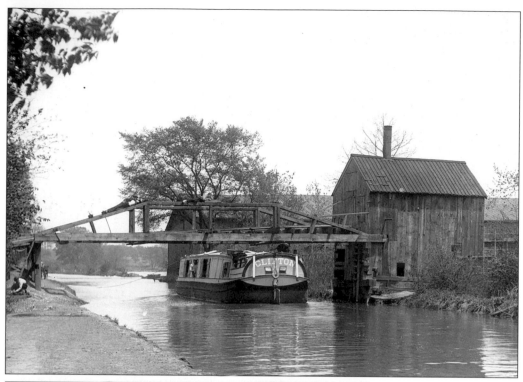

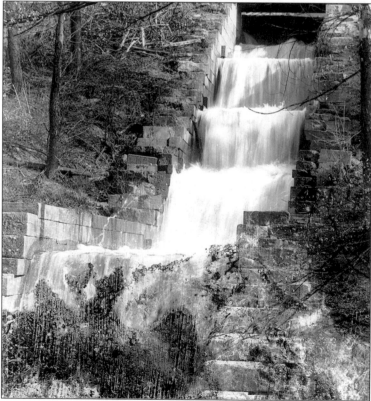

(*above*) This is an example of a drop-down bridge. Freight was loaded onto the canal boat by lowering items through the top of the bridge. It is being moored prior to loading by the man on the far left.

(*left*) The waterfalls of Clifton were created by overflow from the canal. Located just below the Clifton mansion of Scarlet Oaks, the waterfall emptied into the Mill Creek. This picturesque locality was a favorite place for artists, such as Wilmes, to paint. At the top of the waterfall was a pedestrian bridge.

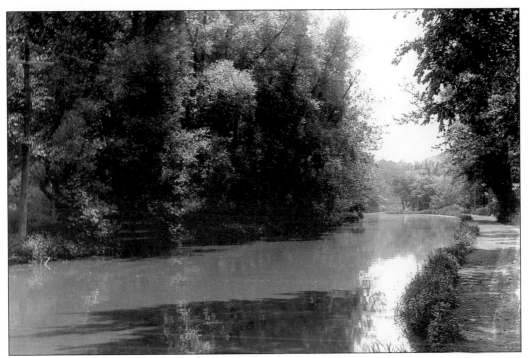

A peaceful spot awaited canal passengers at Clifton.

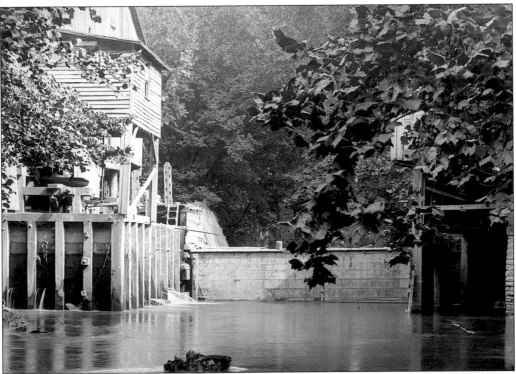

Shown above is another view of a Miami-Erie Canal Lock. Water flows beneath the house, which is built on stilts.

19

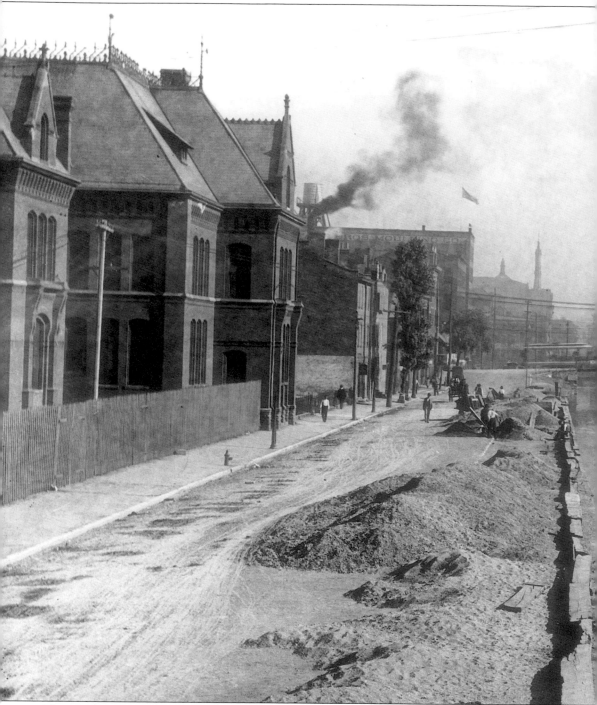

The canal ran right behind Music Hall. This stretch of the canal was enclosed and roofed over, and gondolas sailed on an imitation Grand Canal in the 1888 Centennial Exposition of the Ohio Valley and Central States held at Music Hall. Windows in the back of Music Hall were bricked over as part of a 1894 renovation. The windows let light in onto the back of the newly extended stage, which interfered with performances. On the right is the Cincinnati Commercial

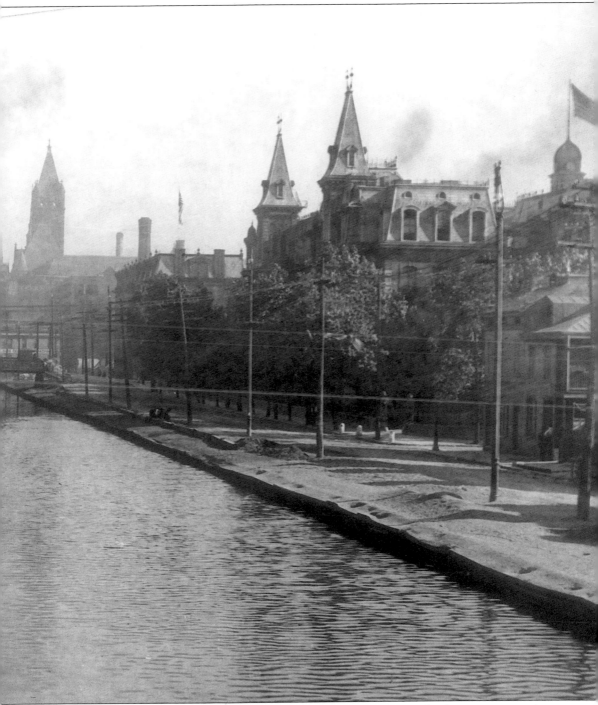

Hospital and Insane Asylum. In the center of the photo is an open-air back streetcar crossing the Twelfth Street Bridge. The fare was a nickel. The spires of the Isaac M. Wise Temple are to the left of center opposite the tower of City Hall. The architect for both Music Hall and City Hall was Samuel Hannaford.

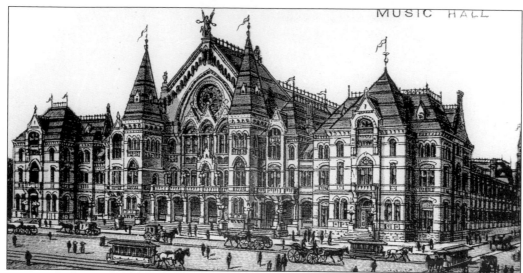

Music Hall is one of the best known landmarks in Cincinnati. The firm of Hannaford and Procter designed it in the High Victorian Gothic style. It contains nearly 3.6 million pressed cherry-red bricks. The construction costs were $446,000. Reuben R. Springer was the impetus for building Music Hall at this location; he envisioned it as hall for music performances, as well as exhibitions to be built on public property but funded privately. In reality, the city put up half of the costs, which were matched by private donations. Springer paid the difference when the donations fell short, rather than see the project delayed. Music Hall was built on the foundation of the 1844 Cincinnati Orphan Asylum, which had moved to Mt. Auburn. Three buildings stand under a single roof. The center building was for music, while the two wings were for art and industrial exhibits. Music Hall functioned as Cincinnati's convention center until the current one was built in 1967. Dedicated on April 8, 1878, Music Hall was named a National Historic Landmark in January of 1975. (William H. Deak Collection.)

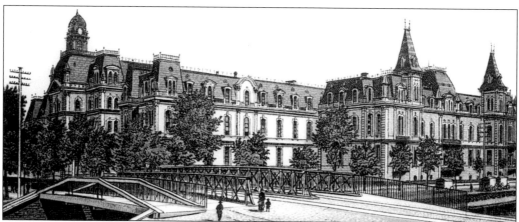

This image is the Cincinnati Commercial Hospital and shows the Twelfth Street Bridge. The hospital was a collection of buildings based upon their function and occupied a city block in either direction. As the hospital was situated by the canal, the smell was blamed at one time for malaria and fevers in the institution. Dr. Christian R. Holmes practiced here and planned a new General Hospital to be built on a hilltop in Corryville. After General Hospital opened in 1915, this building was torn down. Holmes had planned this as a teaching hospital and wanted to situate it close to the University of Cincinnati. (William H. Deak Collection.)

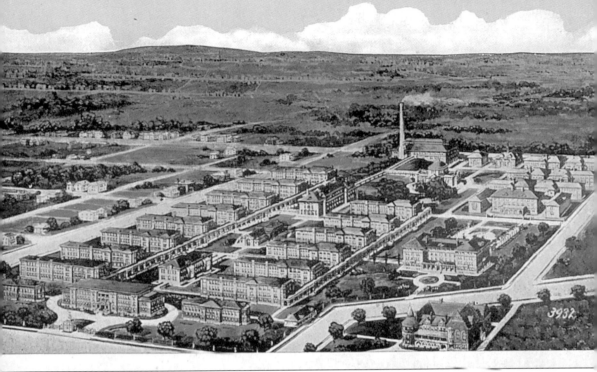

General Hospital was built in the European pavilion style. The idea was to isolate various diseases, and if the contagion could no longer be cleaned away, the individual building could be burnt down. The administration building is center-left bottom. The power plant emits smoke in the background. Years later, these became research pavilions when the new hospital was being built. They were connected underground by a tunnel system. The Altenheim, bottom right, was a home for senior citizens. The architect for the hospital complex was Hannaford and Sons. (Author's Collection.)

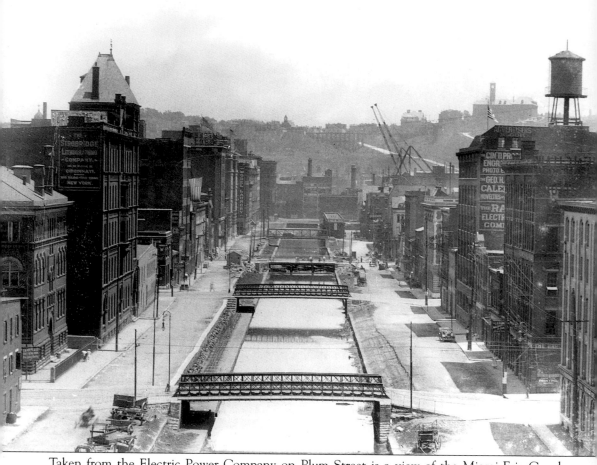

Taken from the Electric Power Company on Plum Street is a view of the Miami-Erie Canal looking east. Holy Cross Monastery (1901) on Mt. Adams is in the background. To the left of it is the Art Museum. Rashig School is the three-story brick building in foreground. Herman Rashig, a school principal, wrote the Ohio Teachers' Pension Law. The multi-story building to the right of center is the Second National Bank, built in 1908. The canal was drained in 1919.

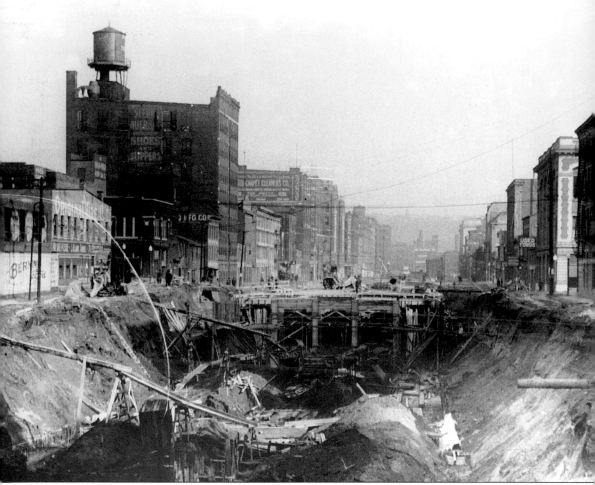

Construction for the subway began along the dry canal beds. Here, in 1922, a subway tube takes shape; Central Parkway was later built over it. To the right is the bi-colored brick and stone building of the Cincinnati Automobile Club on Race Street. It was built in 1904 to house a switching office for Cincinnati & Suburban Bell Telephone Company. In the center is the temporary bridge used for Race Street access.

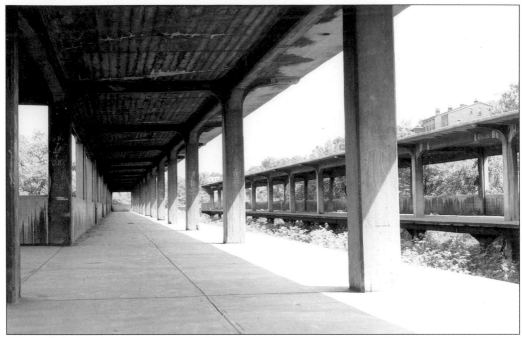

While the subway was never used, above-ground passenger loading platforms were built. Like concrete abstract sculptures, they stand ready to go to nowhere. Many plans have been promoted for the use of the subway tunnels, but none have transpired. (Photographs by William H. Deak.)

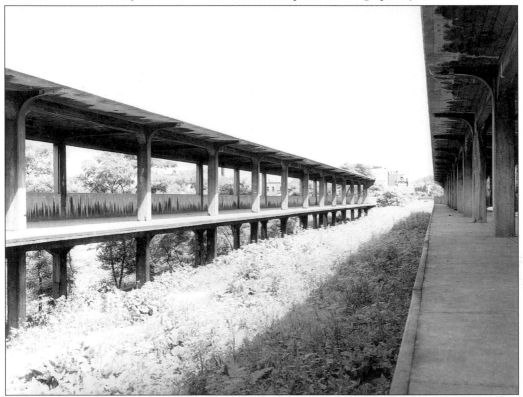

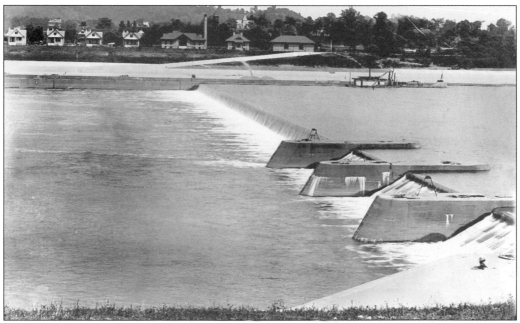

The lock at Fernbank Dam, officially known as Ohio River Lock #37, was begun in 1906 and was completed in 1911 at a cost of 1.4 million dollars. The wickets, made of steel and oak, were raised and lowered by an iron hook manipulated by an attendant in a boat. The utility buildings and residential houses, seen in the background, were working quarters and homes for the staff. At the time of construction, it was the largest moveable dam in the United States. To celebrate the dam's fame, the 1910 Ohio Valley Exposition was held at Music Hall.

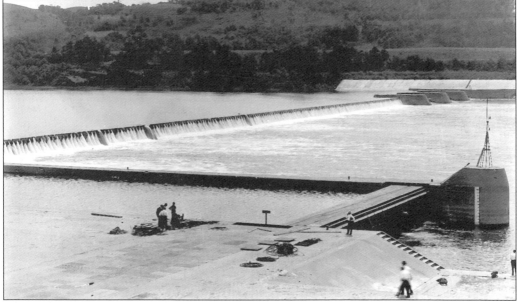

The Fernbank Dam is pictured here at its fullest. Fern Bank was originally subdivided by Charles Short, a descendant of John Cleves Symmes. Large lots were available for those wanting more property than what was available in neighboring Delhi. However, not all living there were affluent, and areas stayed rural until the Fernbank dam was completed.

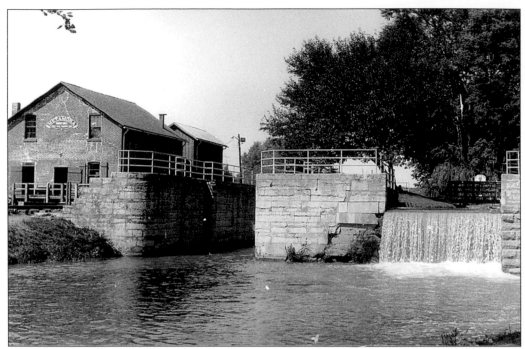

Those with an interest in canals can still visit the remains of the Whitewater Canal at Metamora, Indiana. Of the initial 76-mile canal, only 14 miles remain. The operating lock is an excellent example of what one on the Miami-Erie Canal would have been like. The last covered, wooden aqueduct in America crosses Duck Creek. Originally the canal carried produce and livestock until the railroads expanded into that locale. (Photographs by William H. Deak.)

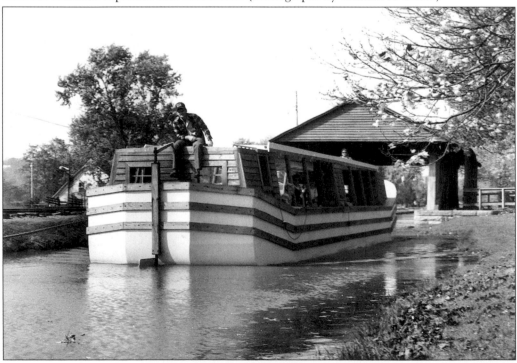

Two

Up the Hills and Down the River

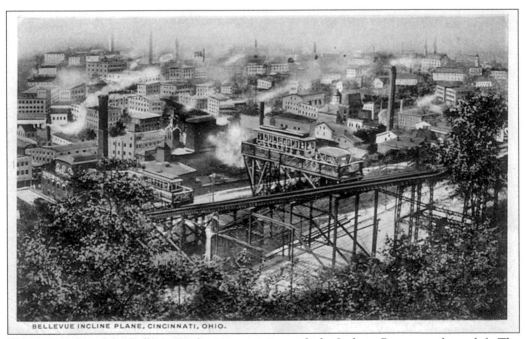

BELLEVUE INCLINE PLANE, CINCINNATI, OHIO.

This postcard is of the Bellevue Incline in operation with the Jackson Brewery at lower left. The valley was covered in smoke from the many breweries and factories. The stone supports for the tracks can still be seen on the Clifton Avenue hill, below Bellevue Park. (Author's Collection.)

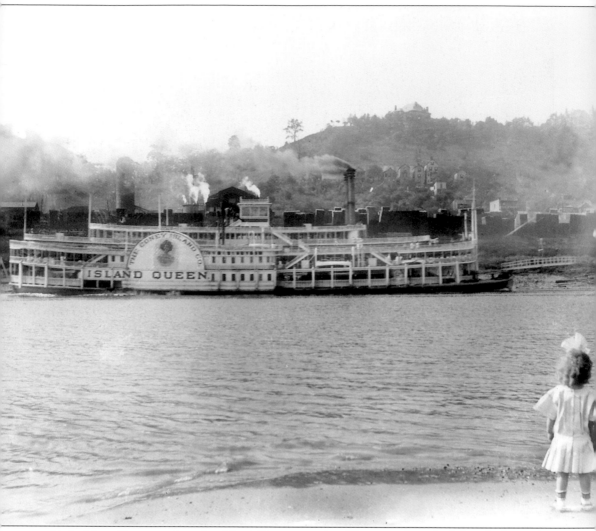

Little Mary Ross watches the *Island Queen* pass by. The steamboat had five decks and was constructed in 1896, costing $80,000. This is the first of the steamboats by that name. She caught fire in 1922 and burned to the water line. Such was the popularity of this excursion up and down the Ohio River that a second *Island Queen* was built.

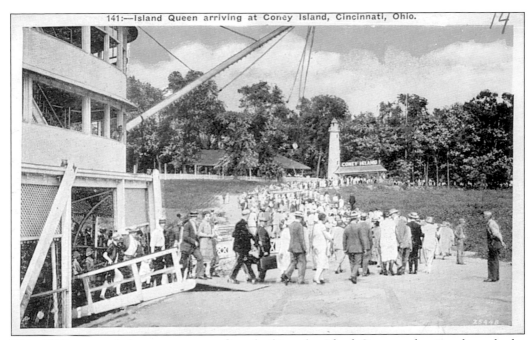

This 1925 postcard shows passengers disembarking the *Island Queen* and going through the familiar Coney Island back entrance. As this area was frequently flooded, a height marker was placed near this entry to show the various flood stages. (Author's Collection.)

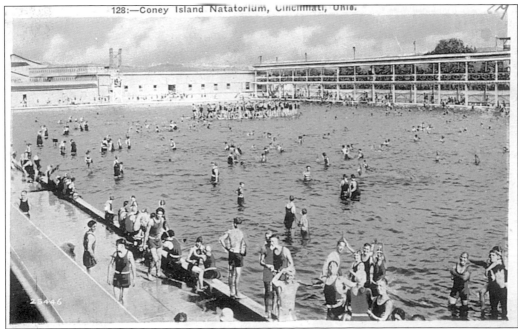

While advertised as "The Children's Paradise," the swimming pool was an attraction for everyone. The pool held 3.3 million gallons. It could hold 10,000 people, but there wouldn't be any room to swim. For decades, it was the largest pool in Greater Cincinnati. In the background, left, is a steamboat. (Author's Collection.)

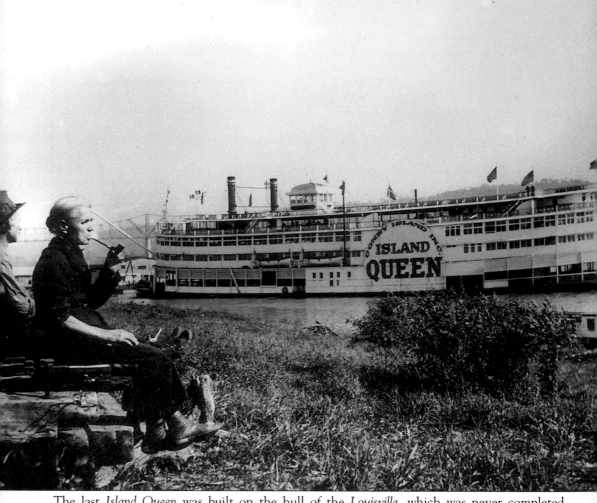

The last *Island Queen* was built on the hull of the *Louisville*, which was never completed. Before Coney Island opened in the summer, the *Island Queen* took passengers up and down the river dancing to Big Band orchestras. Her five decks held 4,000 passengers on the trips from downtown Cincinnati to Coney Island. Passengers could dance the night away in her 20,000-square-foot ballroom covered in 7,000 lights. She exploded in 1947 in Pittsburgh when a spark from a welder's torch started a blaze which spread. It is estimated that a third of all of Coney Island's customers came by the *Island Queen* at this time. No further boats for this purpose were built as the automobile was clearly becoming the most popular way of getting around. (William H. Deak Collection.).

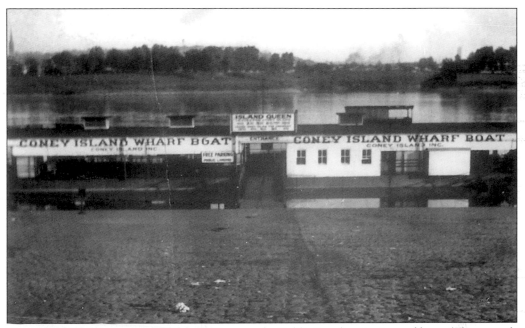

The Coney Island wharf for the *Island Queen* at the Public Landing is pictured here. (Photograph by William H. Deak.)

Passengers awaited their boat ride on this wharf boat. Here, people line the street in the shade of the trees.

Shantyboats rested along both sides of the river. When the river was low, they came aground. Their owners made a living selling fish; coal which had washed from barges gathered on shore; and wood and lumber that floated downriver during floods. They were rousted from both sides of the river as vagrants, and eventually their lifestyle disappeared.

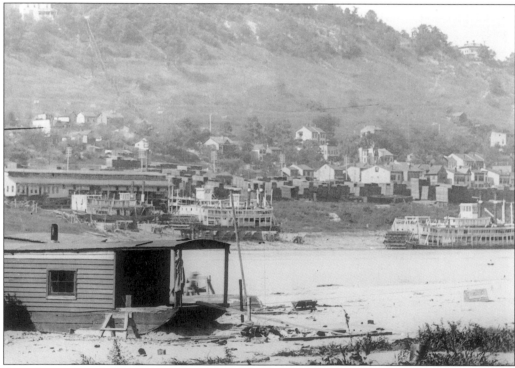

An enlargement of the previous photo shows in the background the Cincinnati Marine Railway and Eureka Dry Dock Yards near the foot of Kemper Lane, across from Dayton, Kentucky. Several steamboats are under construction. The most famous steamboat built by the company was the *Natchez*. When this picture was taken, nearly 1,000 boats had been built by the company in this location.

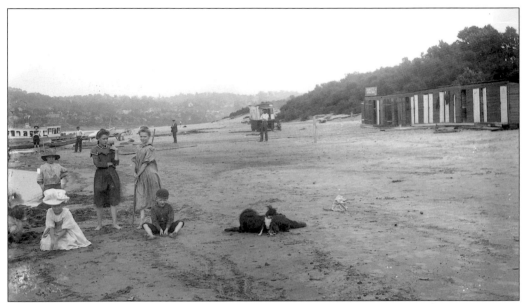

This is Shumate's bathing beach, one of the many white, sandy beaches along the Ohio River on the Kentucky side between Bellevue and Dayton. It was a privately owned beach, and since there were few parks, it was a fashionable place to visit. The water was clear and the sand extended nearly 1,000 feet from the shoreline to the river. To the right are bathing lockers for changing clothes. The beaches were touted as the "Atlantic City of the West."

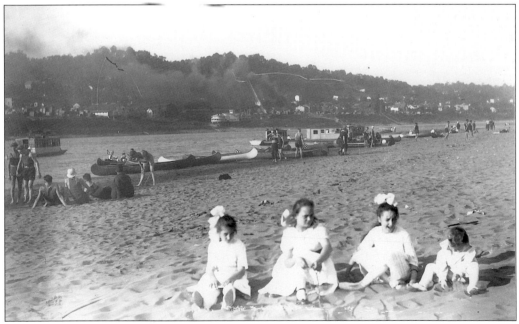

Canoes were offered for rental. A popular spot during the summer, the beach disappeared as dams were installed along the river, regulating water depth and eliminating the low water levels that exposed the beach. Pollution also made swimming undesirable. The river at normal pool stage was nine feet. During the summer, the river would become so shallow that a person could walk from Kentucky to Ohio and stay dry.

A bathing beauty pins up her hair. There was a bathing dress code that was enforced.

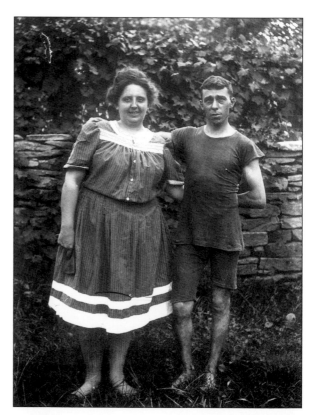

A couple shows off their bathing attire. A long way from a bikini!

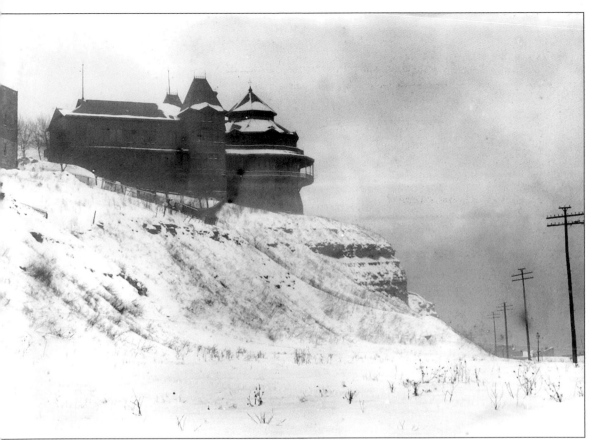

Bellevue House, designed by James W. McLaughlin, had an impressive view of the Mill Creek valley. An ornate octagon 40 feet in diameter, the resort offered food, entertainment, and dancing to those taking the Bellevue Incline to its heights. An orchestra played on a raised dais in the building's center. Bellevue House sold only Christian Moerlein beer; the Christian Moerlein brewery was located on Elm Street, just below Jackson Brewery. The Bellevue House opened in 1876 and was destroyed by fire in 1901. The site was later developed as Bellevue Park.

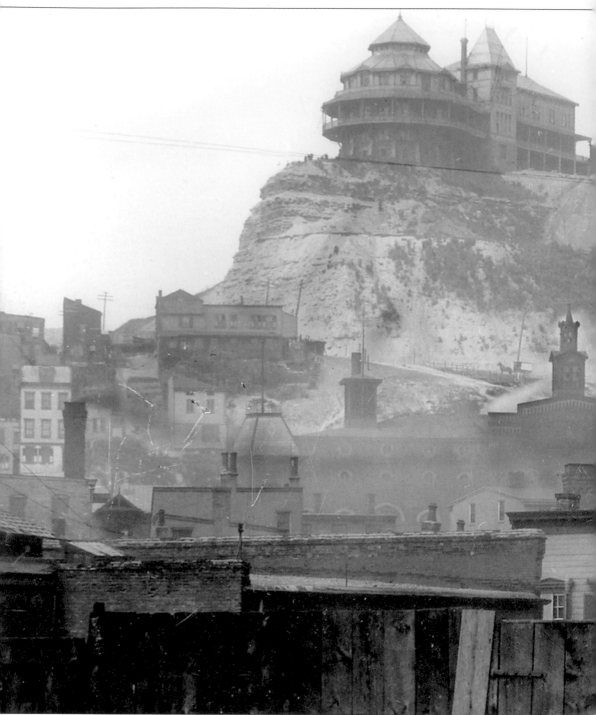

This photo dates to before 1883, when a landslide weakened Bellevue House's foundation and a retaining wall was erected. The Elm Street/Bellevue Incline was built at the head of Elm Street at McMicken Avenue in 1876, closing by 1926. To the far right is the University of Cincinnati's original building, later its Medical College. In the center, a wagon travels up Clifton Avenue

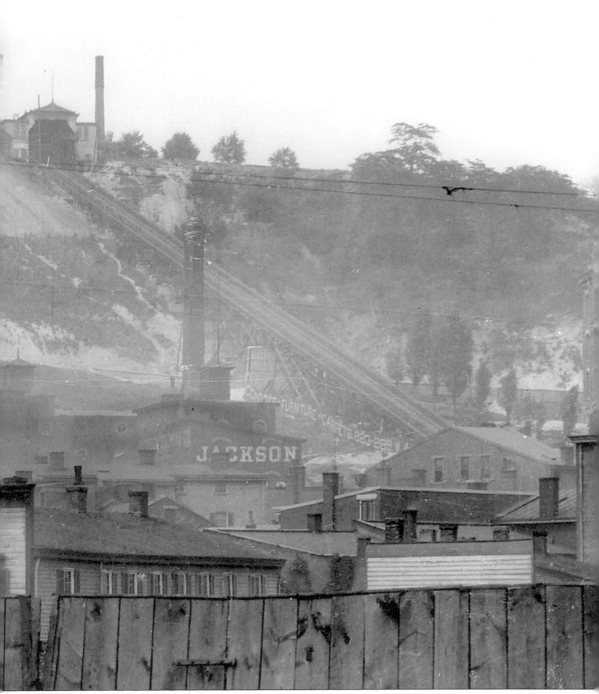

hill. Slightly to the right is the Jackson Brewery on Stonewall Street. Tunnels were built into the hill to cool and store the brewery's beer. A succession of breweries has occupied the building, and the city once provisioned the tunnels for use as air raid shelters.

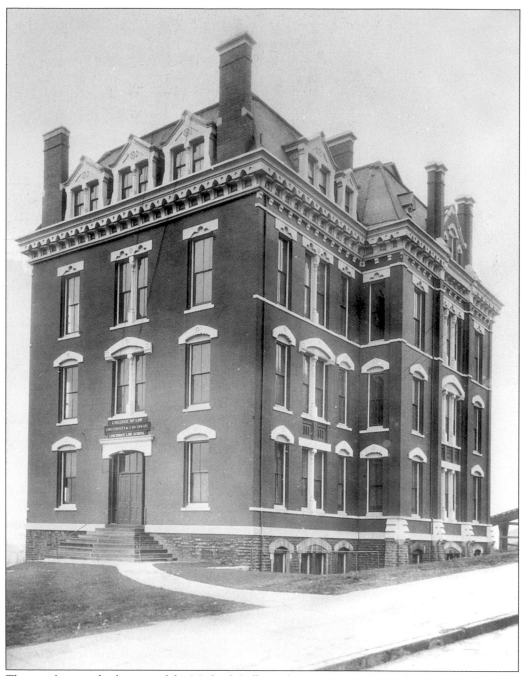

This is a front and side view of the Medical College, then serving as the College of Law, originally McMicken Hall. The tracks of the Bellevue Incline are on the lower right. Charles McMicken was a land speculator who willed a million dollars to the City of Cincinnati for the founding of a university. When the university moved to its current site in Clifton, this building was used for various college departments. The university was owned and operated by the City of Cincinnati until the early 1970s, when it became an institution of the State of Ohio. (Author's Collection.)

The railroad was vital to move products to and from industrial Cincinnati. As more materials were shipped by rail, the use of the canals declined. The Mill Creek Valley with its long, flat plain became a hub where tracks from various railways were laid.

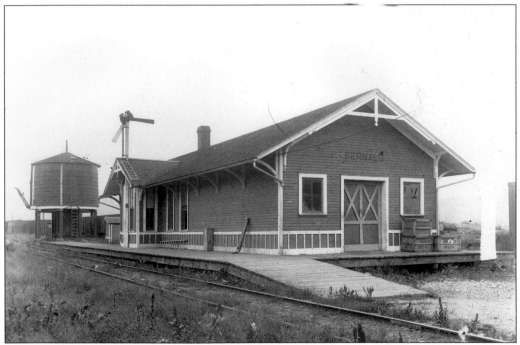

The Fernald railroad station served an agricultural population. This sleepy town didn't expand until Procter & Gamble's Miami Valley Laboratories and the U.S. Government's Fernald Feed Materials Plant were built in the 1950s. Now that area is full of new subdivisions.

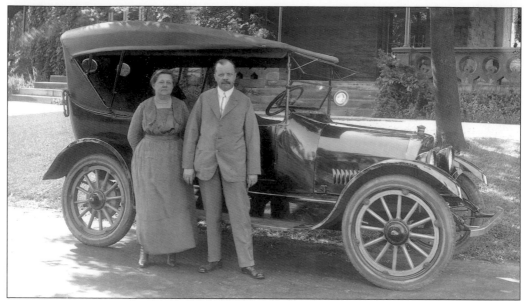

Proud owners pose with their new automobile. The increase in automobile ownership, especially in the middle-class, brought a decline to the steamboat, incline railways, and interurbans, as getting around the city was made easier. It also brought a change in the suburban communities which were once enclaves of the rich.

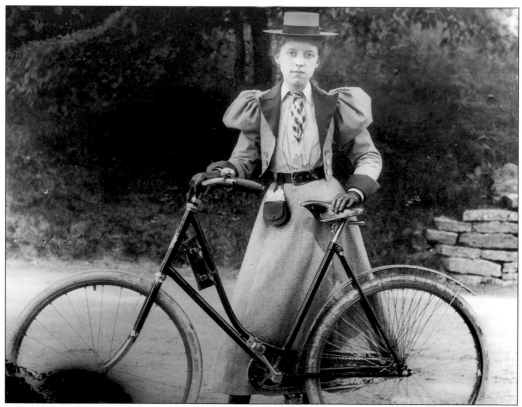

Dolly Schmidt poses in her *c.* 1900 bicycle riding attire.

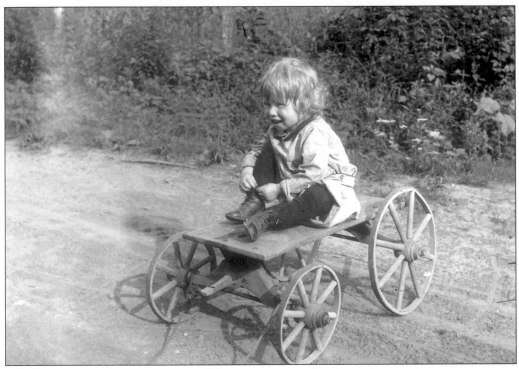

A little tyke waits for someone to pull his wagon—anywhere!

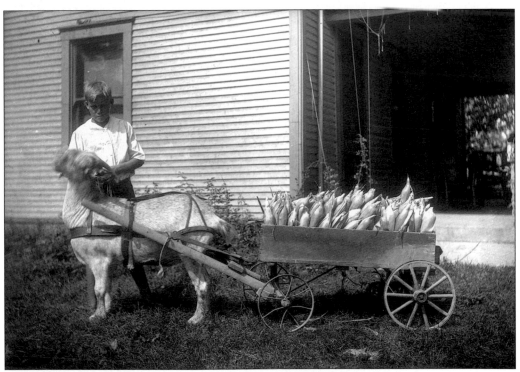

This boy with his goat shows off a crop of home-grown corn.

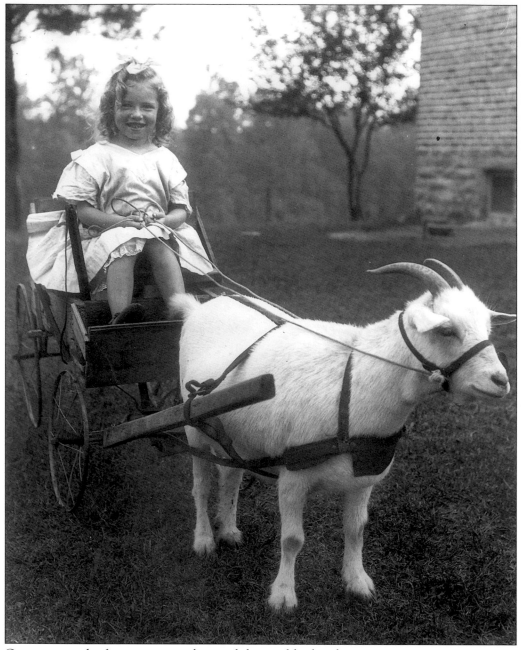

Goat cart was the fun way to travel around the neighborhood.

Three

UPTOWN ... DOWNTOWN

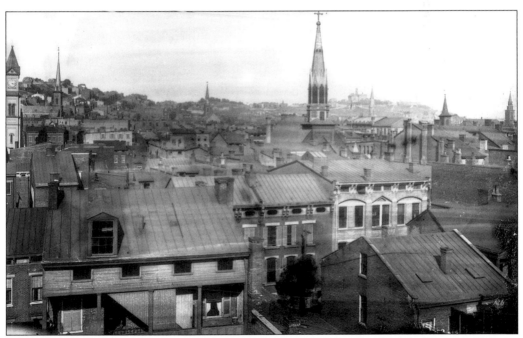

This view is looking east from Liberty Street with St. Francis Seraph Roman Catholic Church on the left and Mt. Adams in the background. The church was designed by James W. McLaughlin, and the cornerstone was laid November 7, 1858. The building was later refaced in orange- and yellow-glazed brick in 1925 to preserve the original church bricks, which were crumbling. According to local legend, the church was built of bricks that were fired in the ovens of its parishioners. Since the ovens did not get as hot as a commercial kiln, the bricks crumbled due to weathering. The site was originally the first Catholic Church in Cincinnati. Although it was just outside the city limits at the time of its construction, within a few years the city's borders were extended to beyond the church.

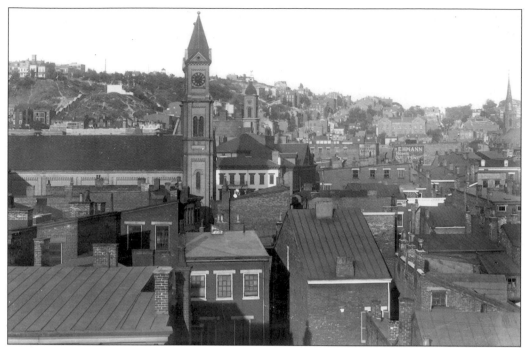

Liberty Street Hill (Prospect Hill) is right of center. A building sign advertises "Ehmann Home Outfitters." Liberty Street was so named because it formed a boundary of the "Northern Liberties" platted in 1833. This area was bordered by Liberty, Vine, and Elm Streets and McMicken Avenue, when McMicken was called the Hamilton Road.

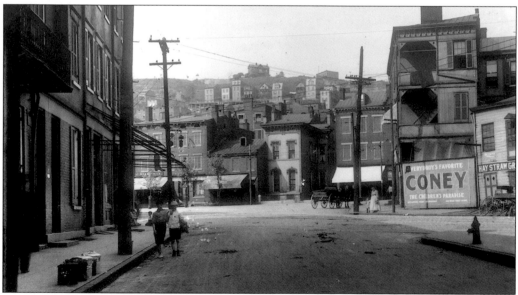

Walnut Street converges at McMicken and Moore Streets. The sign promotes "Everybody's Favorite Coney, The Children's Paradise." The clapboard building next to it sells hay, straw, and grain. The horse-drawn wagon and horse manure in the street underline how the city must have looked and smelled. Everything was horse-drawn, and each animal produced 20 pounds of manure a day.

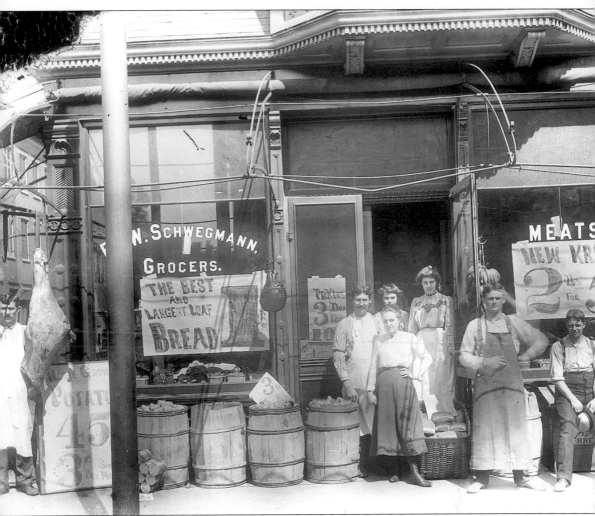

E. & W. Schwegmann grocery store, *c.* 1900, was on the corner of Linn and John Streets. Cincinnati neighborhoods were walking communities. There were little shopping districts in every neighborhood where a resident was within a few blocks of the grocery, saloon, doctor, pharmacy, and other retailers. Often their jobs were a short walk from home. Multiple churches were there too. The convenience of staying in one area to live, worship, marry, shop, and work fostered community pride and helped to divide Cincinnati into 54 distinct neighborhoods.

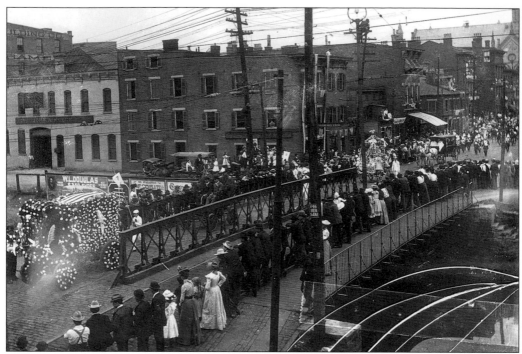

The first Fall Fest Flower Parade crosses the Elm Street Bridge over the canal in 1901.

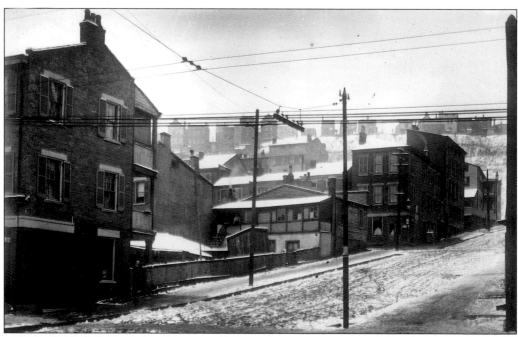

Stonewall Street in Mohawk lies beneath a blanket of snow. Hungarian immigrants populated Mohawk in the early 1900s. Like most immigrants, they settled in a community that was a lot like the home they left—same culture, language, and church. Sohn and Bellevue Breweries and H. H. Meyer Packing Company were the main neighborhood employers. The canal wound through this community, providing transportation for products and raw materials.

Children sled down the Fifteenth Street hill on a snowy day. To the left is Charles Ladewig, Jr. Monuments. Cincinnati's steep streets made for fine sledding in the days before automobiles became common.

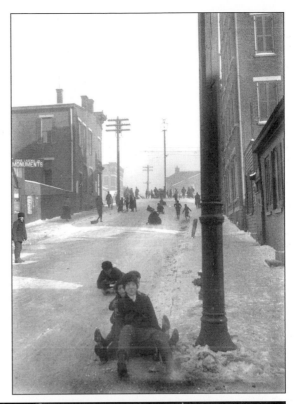

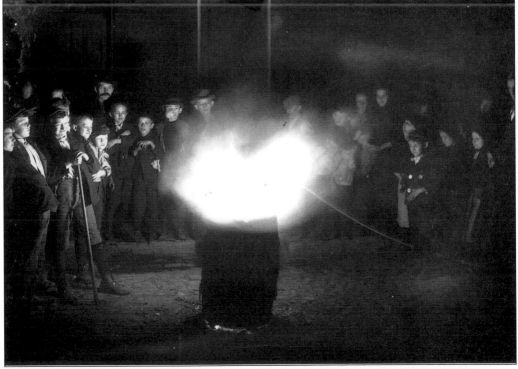

A bonfire lights the night on Pleasant Street near Findlay Market in November 1899.

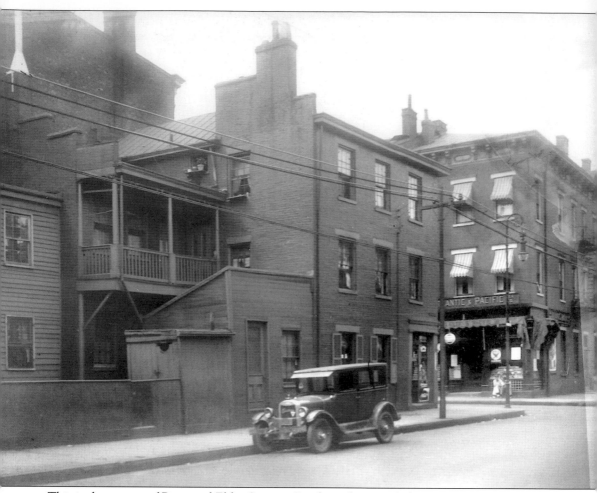

This is the corner of Race and Elder Streets. On the right is an Atlantic & Pacific grocery. On the left, the houses show in detail the outside porches and stairways that are characteristic of Over-the-Rhine. Lots were narrow and outside structures allowed all space to be utilized. The outhouse and perhaps a small garden were in the rear of the property. Narrow walkways between buildings could also open in a shared courtyard.

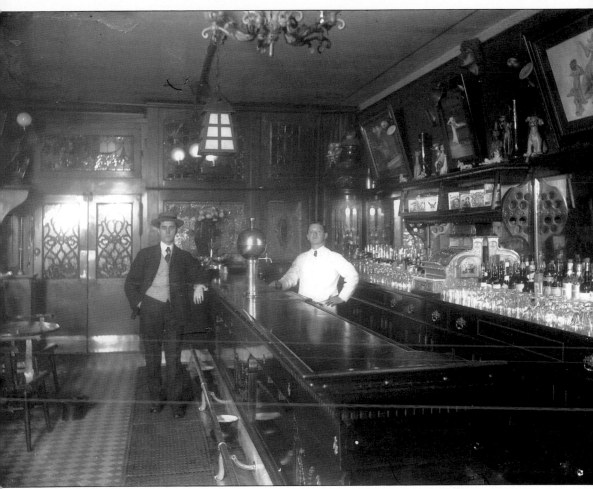

Cincinnati was a city of local taverns. They served as a combination men's club, meeting room, restaurant, employment agency, business office, political intelligence service, and even the savings and loan. A nickel beer bought a free lunch. Over the cash register is a glass case holding boxed cigars. Such was the proliferation of saloons that when Carrie Nation came to town, she said, "I would have dropped from exhaustion before I went a block," upon viewing Vine Street. In one block of Vine Street alone, between Twelfth and Thirteenth, there were 23 saloons.

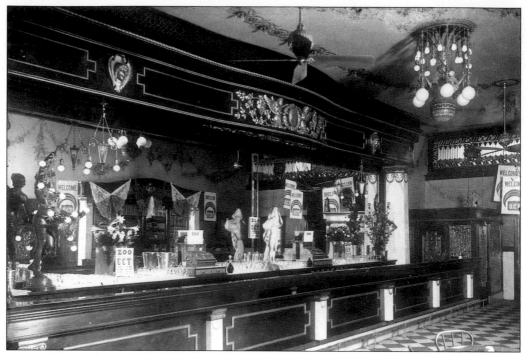

A visit from a zoo group was expected in this saloon. Notice the stenciled ceiling and ornate, gilded cherubs above the bar. Owning your own business was a priority of Germans in Over-the-Rhine.

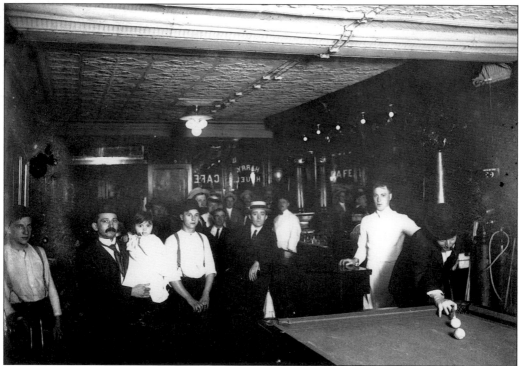

In Harry Heuel's Cafe at 1306 Linn Street, the man known as the "Great Sonnenburg" shoots pool.

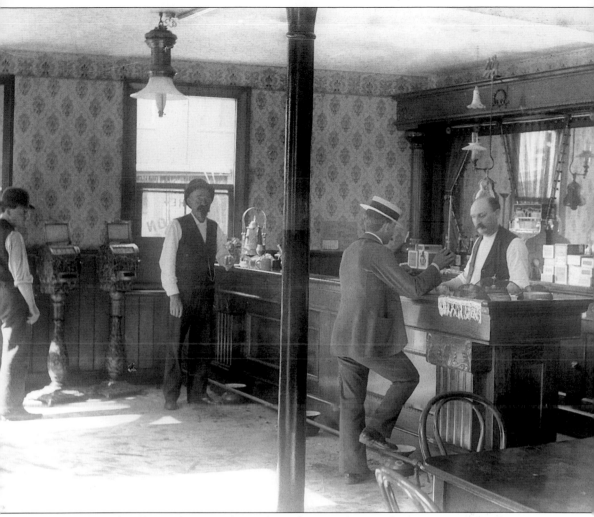

Theodore L. Schaeffer's Saloon was located at Liberty and Central Avenue. A corner location was preferred as it gave the store the most exposure to customers, and if beer was served on Sunday (which was illegal), it was easier to spot the police on the way.

This is a "sanitary barber" shop at 234 Central Avenue c. 1918. The barber is John A. Hubert, the author's grandfather. His was a story typical of the immigrants of that time. He was born in 1893 in Temessag, Hungary. While he was in high school, his father apprenticed him to a barber, paying the barber to teach his son and live with his family. After his apprenticeship and education were complete, John's father sent him to America to avoid Hungarian mandatory conscription, as war was brewing. The family followed a pattern of "chain migration;" John's older brother George was already established in Cincinnati and paid to bring him over. (Author's Collection.)

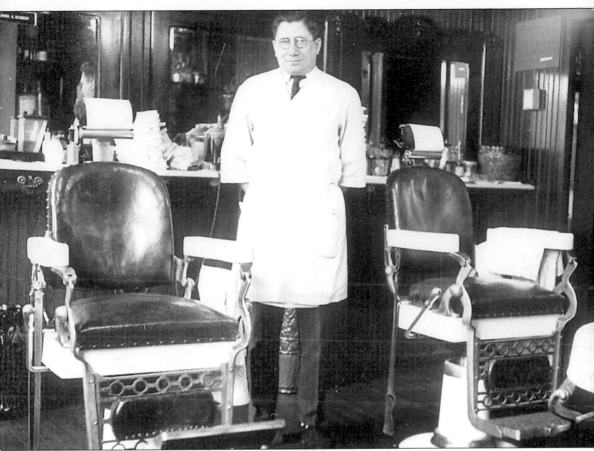

After a 20-day voyage, John arrived in New York in 1909 aboard the *Pannonia*. He boarded on W. McMicken Avenue in Mohawk and started work in a tannery until he could find employment as a barber. He married another immigrant, Margaret Dipong, originally from the nearby village of Kathreinfeld, Hungary, in 1913. They had a family, he opened his own barbershop, and they purchased a house in lower Mt. Auburn. He was naturalized in 1916 and was very proud to be an American. (Author's Collection.)

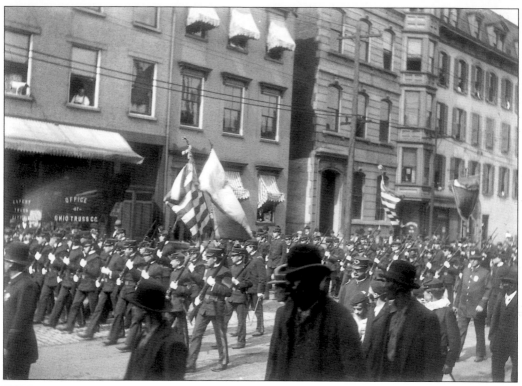

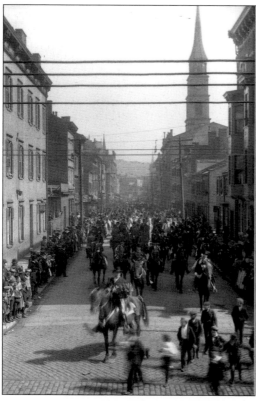

The Grand Army of the Republic met in Cincinnati September 5–10, 1898. Cheered along their parade route down Vine Street and over Twelfth Street, they marched in their distinctive double-breasted, dark-blue coats with bronze buttons. An organization of Union veterans, in 1890 they had 400,000 members. Annual state and local meetings were called encampments. Their goals were fraternity, charity, and loyalty. The GAR provided relief funds for needy veterans, widows, and orphans and set up orphanages in several states. They also raised funds for monuments, commemorative plaques, and equestrian statues to be placed in town squares and parks. Members were encouraged to preserve Civil War history and pass their mementos on to museums. One of the reasons Cincinnati was picked for a national encampment was its nearby sandy beaches. So many attended this encampment that the local transit system was overwhelmed and broke down, stranding thousands of conventioneers at the zoo. The local GAR headquarters was on Sixth Street between Vine and Race.

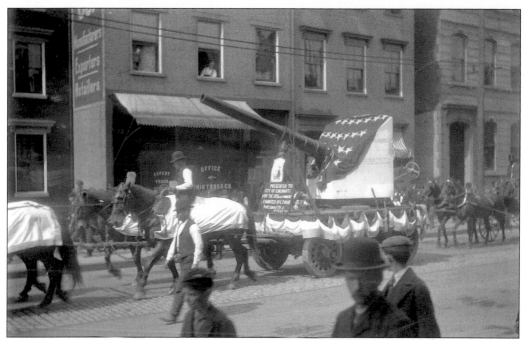

In the background is the office of the Ohio Truss Company. The plaque on the cannon reads, "Presented to the City of Cincinnati by the U.S. Government, Exhibited by C. P. Shaw(?), Portsmouth, O." The GAR presented cannons and fieldpieces to cities and towns.

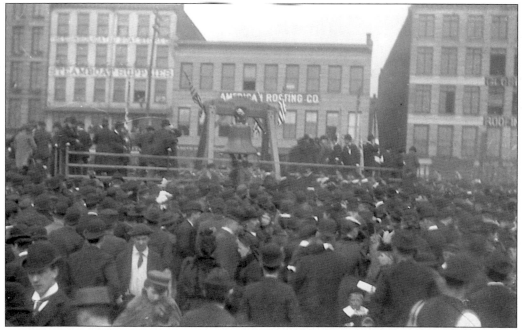

A replica of the Liberty Bell goes past the American Roofing Company and another business selling steamboat supplies. The proud patriotism of the GAR led to the designation of May 30 as Decoration Day for laying flowers on the graves of Union soldiers. As the Civil War veterans passed away, it became Memorial Day to honor soldiers of all wars.

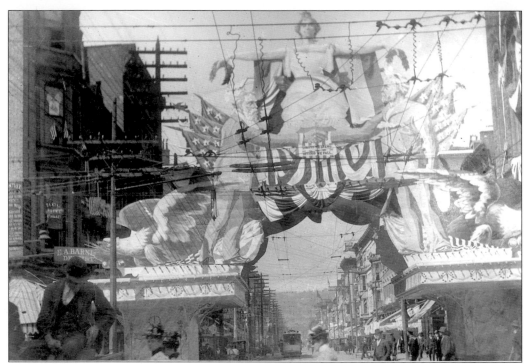

(*above*) The Arch of Peace spanned Race Street at Fourth. One of the tenets of the GAR was uniting a divided country. Here, soldiers from the Union and Confederacy clasp hands, below which is the motto "United we Stand, Divided we Fall."

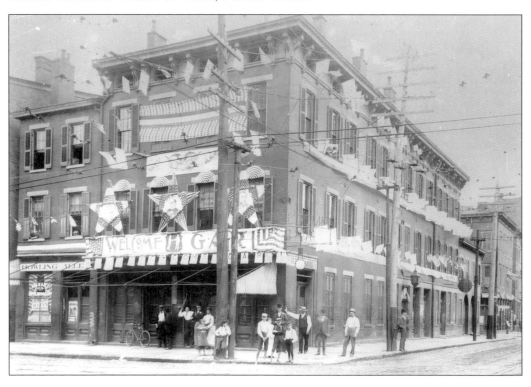

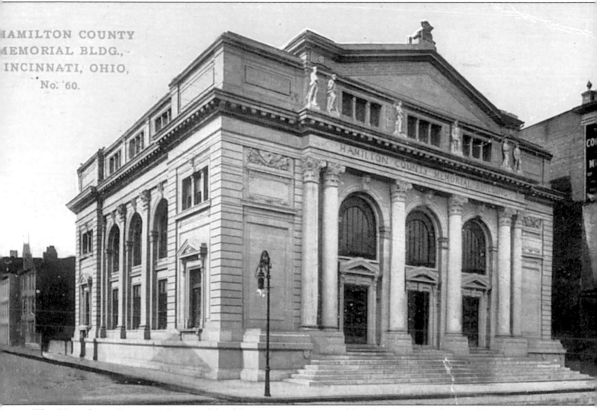

The Hamilton County Memorial building was constructed by the GAR and Hamilton County in 1908 as a memorial to soldiers, sailors, and marines. Inside are tablets, relics, and flags from the Revolutionary War, Civil War, and Spanish American War. Designed in the Beaux Arts style, its architect was Hannaford & Sons. The six statues above the doors were sculpted by Clement Barnhorn, an instructor in the Cincinnati Art Academy and a friend of Frank Duveneck. Inside, the walls were stenciled and frescoed by Francis A. Pedretti & Sons. A small auditorium is decorated with the words: "patriotism, will, integrity, manliness, martyrdom, philanthropy"—all virtues to the GAR. Among its collections are a plaque made from the metal of the USS Maine. A major restoration of the building was completed by the Miami Purchase Association, under the direction of Mary Ann Olding and the Board of County Commissioners. To the right is the College of Music of Cincinnati. (Author's Collection.)

(*opposite*) The James Keenan Bowling Alley was on the southwest corner of Liberty and Freeman Avenue. The West End Republican Club met on the second floor. The GAR evolved from a fraternal organization into a political force. No Republican was nominated for the presidency from 1868 to 1908 without its endorsement. Five presidents were members: Ulysses S. Grant, Rutherford B. Hayes, James Garfield, Benjamin Harrison, and William McKinley. The center of the large stars bears portraits of Grant, McKinley, and Garfield.

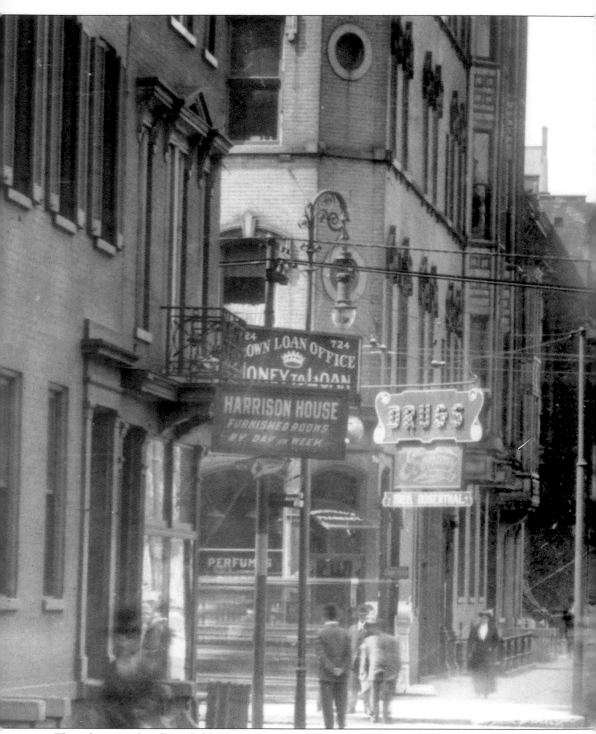

This photograph of Garfield Place (Piatt Park) was taken looking west in 1906. Theodore Rosenthal owned the corner drugstore, and the Harrison House offered furnished rooms by the day or week. Mid-square, the Motor Supply Company sold wholesale and retail. This block was torn down for the Garfield Place Doctors Building (1923). In the background, at right, is the

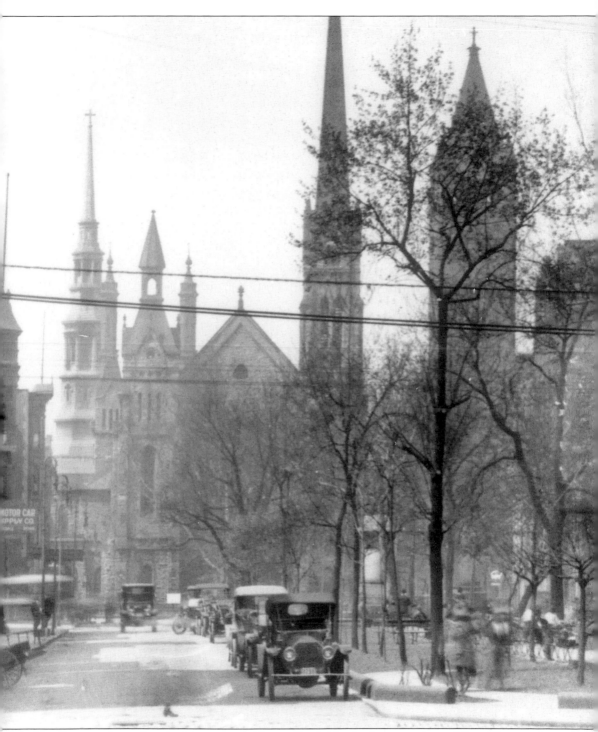

shrouding on the pedestal of the statue of James Garfield, which was in the middle of Race and Eighth Streets. It wasn't moved back into the park until 1915, when automobile traffic rendered it a nuisance. Covenant First Presbyterian Church, center back, still has a spire. Notice the perfect little foot crossing the street while the body blurs away.

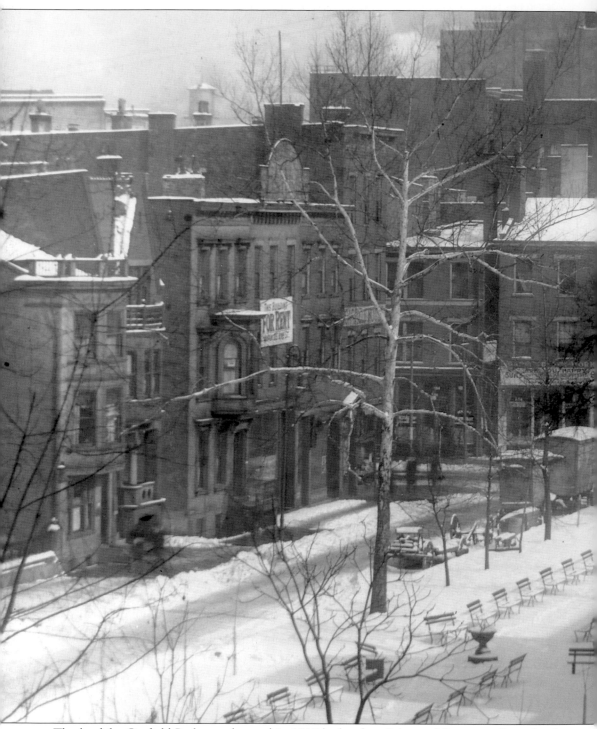

The land for Garfield Park was donated in 1817 by brothers John and Benjamin Piatt for the city's use as a marketplace. Instead it was developed as a park. In 1940, Garfield Park was renamed Piatt Park. This view is looking east. In the center are the buildings that were torn down so that the current public library of Cincinnati and Hamilton County could be built

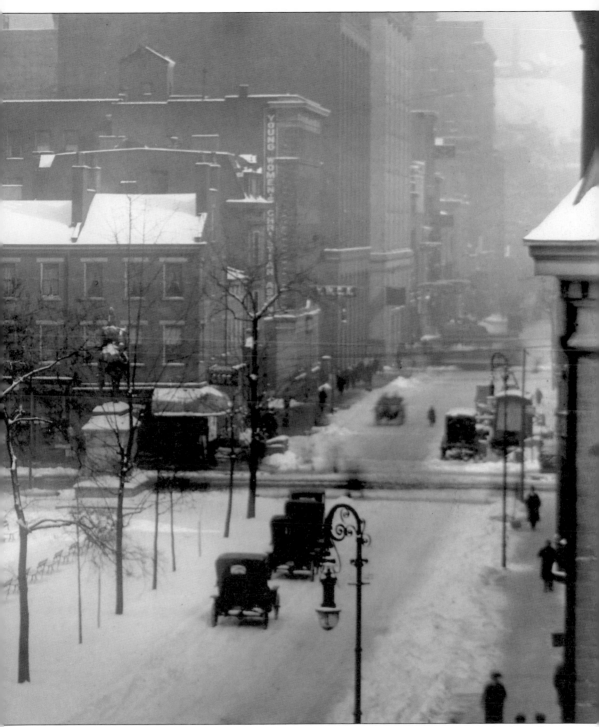

(1955). Next to the corner is the YWCA. A time capsule was buried in Garfield Park and opened in 1989. The contents were a bandana for the 1885 Grover Cleveland presidential election, a three-dollar bill from the 1800s, paper currency amounting to less than a dollar, several newspapers from 1888 (including several in German), and Colonial-era currency.

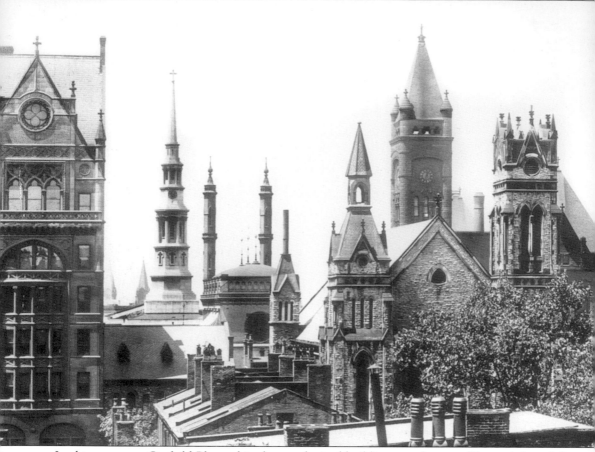

Looking west on Garfield Place, this cluster of spired buildings can be seen. Pictured, from left to right, are the Odd-Fellows Temple, St. Peter in Chains Cathedral, Isaac M. Wise Temple, City Hall, and Covenant First Presbyterian Church. St. Peter in Chains was designed by Henry Walter and was consecrated in 1845. The Isaac M. Wise Temple was designed in 1866 by James Keys Wilson in the Moorish-Byzantine style. Notice the decorated domed roof and minaret-like spires. City Hall was built in 1888–1893. Designed by Samuel Hannaford in the Richardsonian-Romanesque style, the building's rough stone contrasts with the smooth exterior of St. Peter in Chains. Covenant First Presbyterian Church was designed in 1875 by William Walter, son of Henry Walter, with a tower bell thought to be cast by Paul Revere. The church also contains furniture carved by William and Henry Fry.

Pictured here is an 1895 drawing of the front of the Isaac M. Wise Temple/Plum Street Temple. It was the first temple built in the style reminiscent of the Alhambra. The lot was purchased in May 1863 with a pledge of $40,000 for the lot and the start of the building. The Civil War delayed construction until 1865. When the temple was dedicated in August, 1855, the total cost was $263,525. Wise requested this specific style of architecture to harken back to the Golden Age of Spain, where Judaism flourished for four centuries. The temple is on the National Register of Historical Places and was restored in 1995. It houses an 1866 Koehnken & Company organ, the only one made by the company still in existence. Dr. Isaac Meyer Wise (1819–1900) was the father of Reformed Judaism and founded Cincinnati's Hebrew Union College. (William H. Deak Collection.)

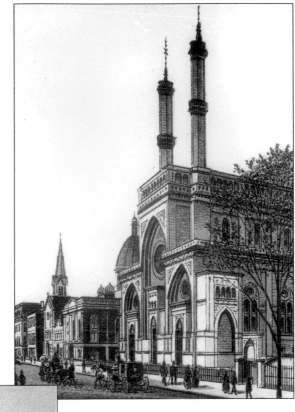

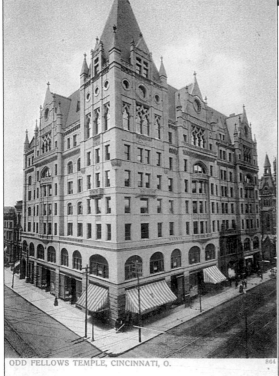

ODD FELLOWS TEMPLE, CINCINNATI, O. 864

The Odd Fellows Temple was also designed by Hannaford & Sons. Completed in 1893, it stood on the corner of Seventh and Elm streets. It held the general offices of the Queen & Crescent System railway. The Odd Fellows founded the Mt. Washington Cemetery in 1855. The Independent Order of Odd Fellows was a fraternal organization with roots in England. (Author's Collection.)

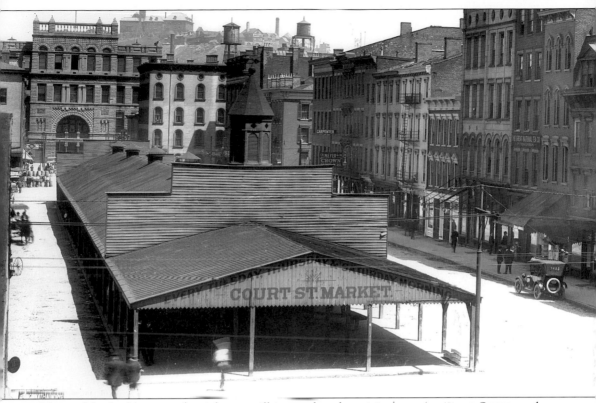

Many of the buildings on the right are still in use, but the original wooden Court Street market was demolished in 1915, the year this picture was taken. Razed by order of the board of health, it had replaced an earlier structure (1829–1864), named the Canal Market for the canal a block away. Louis C. Graeter, founder of Graeter's Ice Cream, started his business with a milkshake stand inside the market. Court Street was widened to accommodate the width of the market house. The cupola held a bell to signal the beginning and end of market day. Underneath the building were stone-lined tunnels, used as hog runs to the slaughterhouses near the market—the tunnels became a refuge for citizens during the courthouse riot of 1884. Mt. Adams, with the Rookwood Pottery and Holy Cross Roman Catholic Church and Monastery, is in the background. Behind the market house is the courthouse.

(*opposite*) Samuel Hannaford was born April 10, 1835, in Devonshire, England. His family settled on a 38.5-acre farm in Cheviot in 1845. Samuel enrolled in Farmers' College in College Hill in 1853. By the next year, he was working with an architect. He married Phoebe Statham, daughter of Cheviot's pioneer David Eldridge Statham. As his family grew, Samuel built a house on the northeast corner of Derby and Winton Roads in Winton Place, his home until his death in 1911. Hannaford married twice after Phoebe died of typhoid in 1871. His second wife was Anna Belle Hand, daughter of Sylvester Hand, who had originally platted Winton Place. Following her death, he married Ada Louise Moore, who outlived him. Professionally, he formed several partnerships in the early years. His sons Harvey Eldridge and Charles Edward joined him to form Hannaford & Sons in 1887. After Samuel's death, this continued to be a prominent architectural firm, designing, among other things, Cincinnati General Hospital, Deaconess Hospital, Ohio Mechanical Institute, the annex to the state capital building in Columbus, and the original buildings for Ohio State University. Samuel was the first and only mayor of Winton Place. He helped to develop the first building codes for Cincinnati, urged smoke abatement, and championed the building of the Mill Creek Valley sewer system. (Sue Hannaford Scheld Collection.)

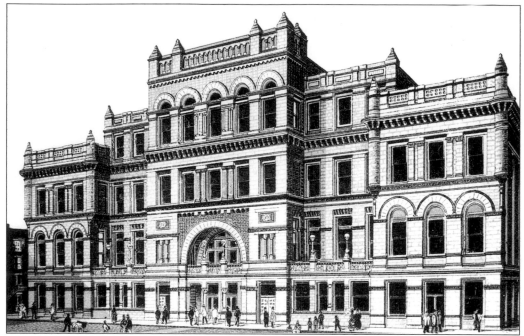

Designed by James W. McLaughlin, this completely fireproof courthouse replaced the one burned in the courthouse riot of March 1884. It was outgrown in three decades and was replaced with the current Hamilton County Courthouse. (William H. Deak Collection.)

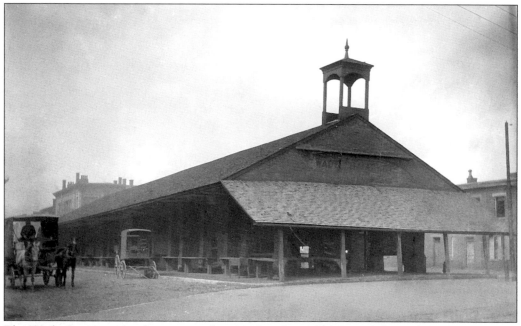

The Wade Street market house started in 1847 and stood between John and Cutler Streets. It had been built of lumber salvaged from the First Presbyterian Church, the first church (1792) in Cincinnati. The market was owned by the city, which charged stall rent. Smaller than nearby Findlay Market, it was one of a dozen fresh food and meat markets available to shoppers in the Over-the-Rhine and downtown. It was torn down in 1898.

St. Johannes (John) the Baptist Roman Catholic Church's rectory on Green Street is pictured here. The church was on the corner of Elder and Green Streets. Built in 1845, the brick building was torn down in 1969.

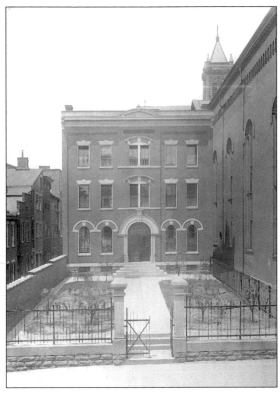

This view is looking over downtown south from Wilmes's home at 1560 Elm Street in 1898.

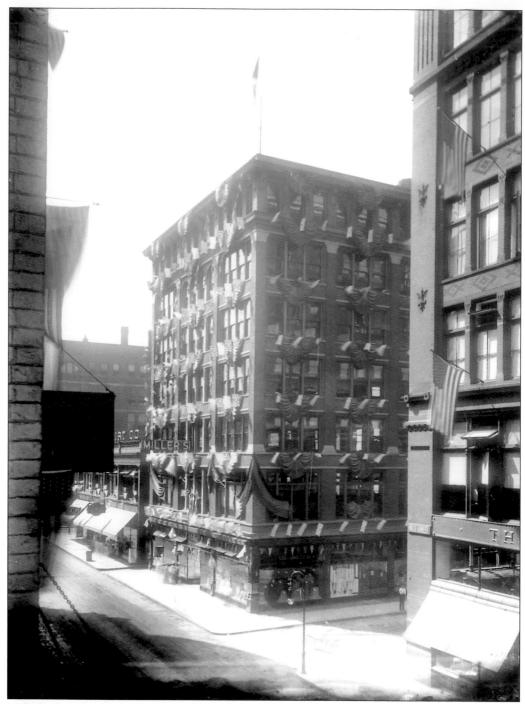

Miller's department store was on Race Street. The building to the right is the John Shillito Company, designed by James W. McLaughlin in 1878. When it was built, it was the largest department store in the country under one roof and featured a domed atrium with the selling floors ringing the sides.

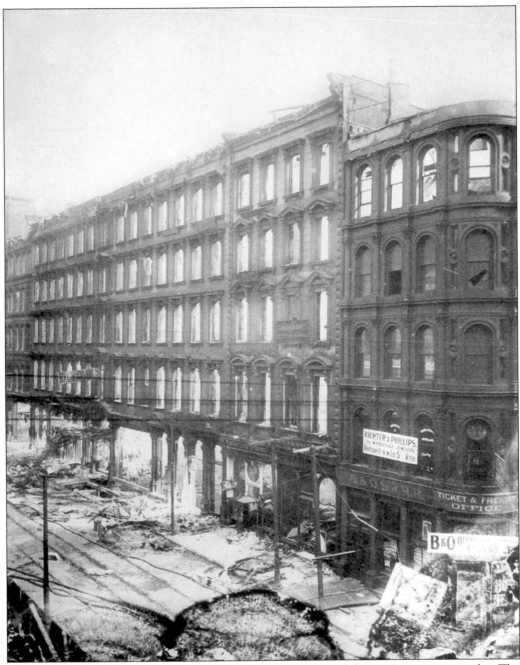

The Pike's Opera House fire on February 26, 1903, was one of the city's most spectacular. The building was constructed on the site of the first Pike's Opera House (1859–1866) which also was destroyed by fire. Today, Provident Tower on Fourth Street stands at this location. Samuel N. Pike was a wealthy liquor dealer and land speculator who became enamored of Jenny Lind after hearing her sing on tour. He wanted to build an opera house in Cincinnati worthy of her voice. It was in the first building of that name that Junius Brutus Booth Jr. was starring in a play when he heard the news that his brother had shot President Lincoln. Pike's Opera House was home of the Cincinnati Symphony Orchestra until 1896, when the orchestra moved to Music Hall.

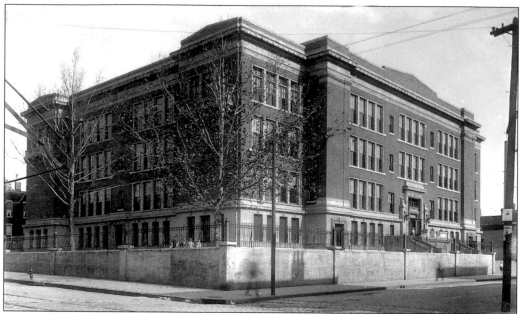

Sands School, 940 Poplar Street, was opened in 1912 and was named for George F. Sands, former school principal and president of the National Baseball Association. (1867–1868). It was changed from a neighborhood elementary school to a specialized school, Sands Montessori.

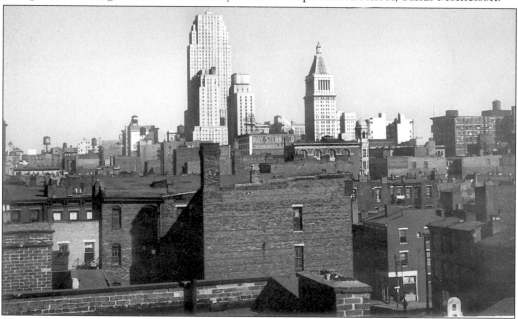

The familiar Cincinnati skyline is shown here *c.* 1940 with the Carew Tower, which was built in 1930. John Carew was the founder of Mabley & Carew department store. The tower is 48 stories tall with an Art Deco arcade incorporating Rookwood tiles running through the ground floor. The construction of both the Carew Tower and the Union Terminal (1929–1933) gave work to hundreds during the Depression. These construction projects were a tremendous statement by the city that prosperity would return. The Netherland Hilton hotel and Mabley & Carew were the primary tenants of the new Carew Tower. (Photograph by William H. Deak.)

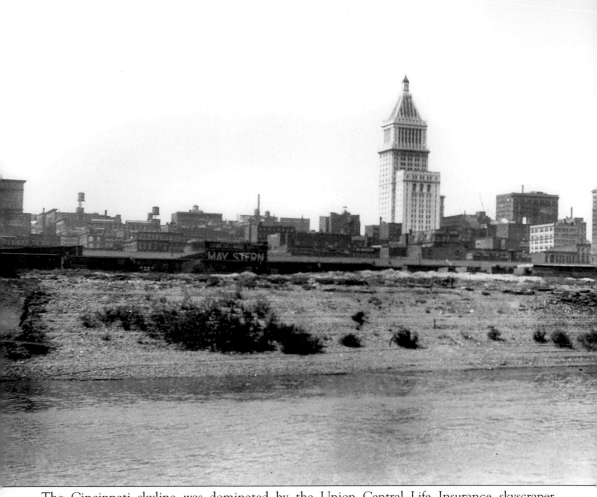

The Cincinnati skyline was dominated by the Union Central Life Insurance skyscraper completed in 1913. At that time, it was the tallest building outside of New York City. Faced with marble and terra-cotta, it is 20 stories high with an additional 4-story temple-pyramid on top. It was built on the site of the Chamber of Commerce building which burned. Stone blocks from the Chamber of Commerce building are now in Burnet Woods opposite the College of Design, Art, and Architecture.

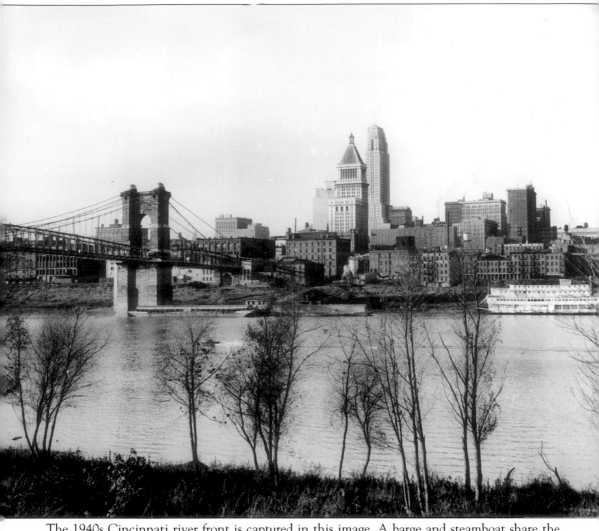

The 1940s Cincinnati river front is captured in this image. A barge and steamboat share the Ohio River. Before urban renewal, the city extended closer to the river. Construction on the John A. Roebling Suspension Bridge began in 1857, and the bridge opened to traffic in January 1, 1867. Pedestrian toll was 15 cents, while other tolls ranged from a dime to 15 cents. The span is 36 feet wide and 2,252 feet long and was the longest span in the world when it was finished. Its initial cost was two million dollars. After completing this project, Roebling next built the Brooklyn Bridge. (Photograph by William H. Deak)

Four

EMERALDS
OF THE CITY

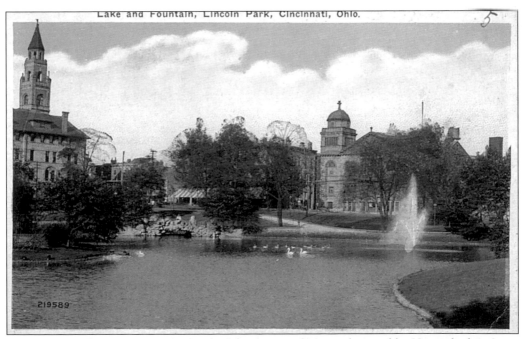

On the left is the convent and school of the Sisters of Mercy, designed by Hannaford & Sons. A teaching order, it founded Edgecliff College. Lincoln Park, developed in 1858, encompassed 10 acres. At the center of the lake was a gazebo-topped island. (Author's Collection.).

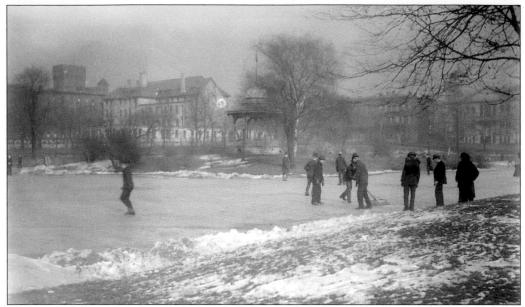

Lincoln Park's lake was a winter skating pond for city residents. Lincoln Park was in the West End at the termination of Freeman Avenue. This park filled a square city block and was primarily a lake. The site was earlier used as Potter's Field. The statue of Captain John J. Desmond, who died during the 1884 courthouse riot, once stood in Lincoln Park, but was moved to the courthouse once the park was abandoned. A spot of green on summer nights, the park slept thousands escaping the heat of the tenements. When the city decided to locate Union Terminal nearby, the tenements were razed and a city dump filled in, and Lincoln Park became the esplanade approaching the terminal. In the photo, the crenellated tower on the left was the Ohio National Guard Armory, designed by Samuel Hannaford in 1889.

The armory was home to the 1st Regiment, Ohio National Guards, which fought in France during World War I. It was constructed of the same yellow-glazed brick as the convent next door. (William H. Deak Collection.)

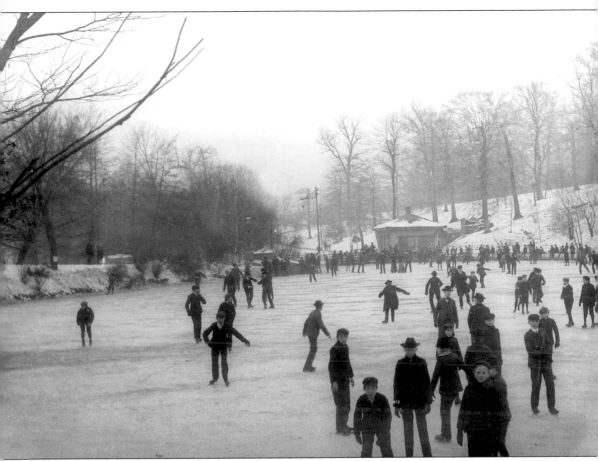

Ice skaters enjoy a winter's day in Burnet Woods. The park was laid out by the famed landscape architect, Adolph Strauch, who also planned Spring Grove Cemetery, Eden Park, and Mt. Storm Park. The property was owned by Judge Jacob Burnet and was part of his estate that extended to McMillan Avenue.

The Burnet Woods Lake dates from 1875 and is artificial. The park is currently about half of its original size, the rest being occupied by the University of Cincinnati. William S. Groesbeck, son-in-law-of Judge Burnet, provided a trust to provide free summer concerts. The Trailside Museum was built by the WPA in 1942. Dolly Schmidt is pictured here at Burnet Woods Lake.

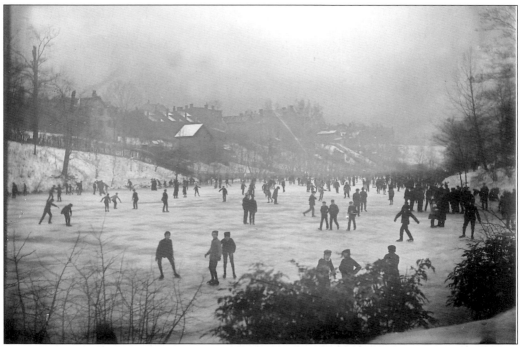

Canoeing was a popular past time. In the background is the dock and shelter house. Strauch designed all the buildings in the park to be rustic.

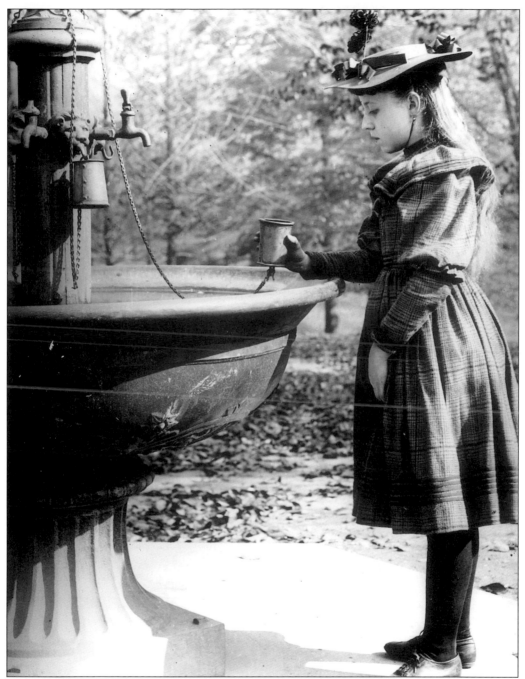

The drinking fountain in Burnet Woods once used communal cups for water. By 1912, newspaper articles from doctors were appearing about the unsanitary common cup fountain. It was not until 1914 that such fountains were replaced by the Cincinnati produced Murdock "Bubble-Font" that operated on demand by use of a foot pedal. These columnar fountains cost $16 apiece and were an advance in stopping the spread of communicable disease. They were installed in parks, playgrounds, and anywhere people would gather. Sturdy and maintenance free, some examples still survive from this period.

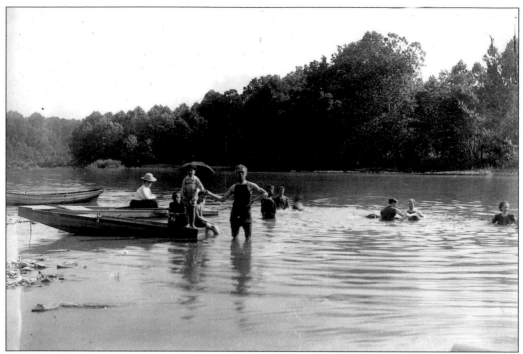

The summers are ideal for swimming and boating. Useable small lakes and streams once abounded. Most have disappeared from the urban landscape, either because of development or pollution.

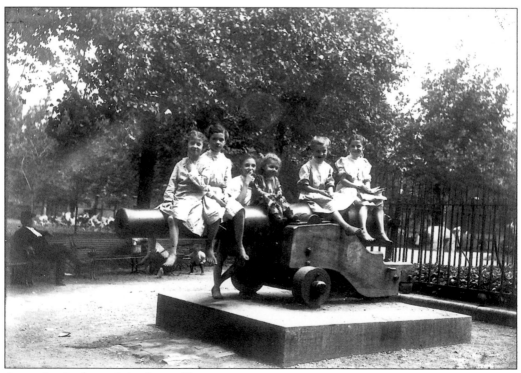

An outing in the park is pictured here.

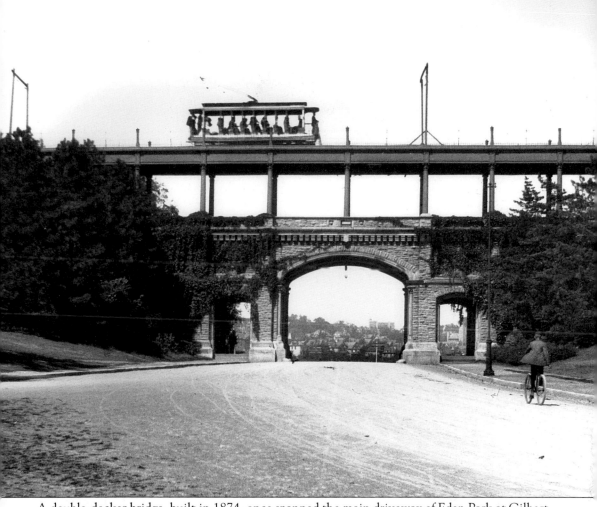

A double-decker bridge, built in 1874, once spanned the main driveway of Eden Park at Gilbert Avenue. The bridge continued over Gilbert Avenue and spanned the valley of Reading Road. The open air streetcar is the Zoo-Eden route. The first bridge level was open to pedestrians. Eden Park was named for the "Garden of Eden" vineyard that earlier had covered its slopes. Nicholas Longworth owned the land, and as early as 1846, offered the land for sale to the City of Cincinnati for a park. The city rebuffed his offer then, but in 1866 approached his heirs. The city thought the land would be a good site for a much needed reservoir. Eventually the city acquired 200 acres for the park. (William H. Deak Collection.).

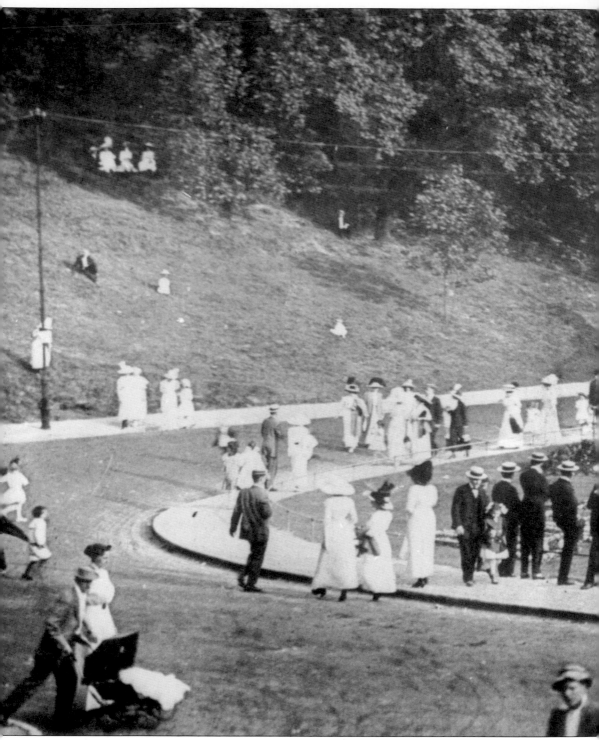

Eden Park was crowded in 1905, perhaps for a Sunday outing. The Mt. Adams Incline and street cars helped to make this a popular place to gather. The gazebo originally covered a spring whose waters were rumored to have medicinal qualities. The familiar gazebo house dates to 1904. Adolph

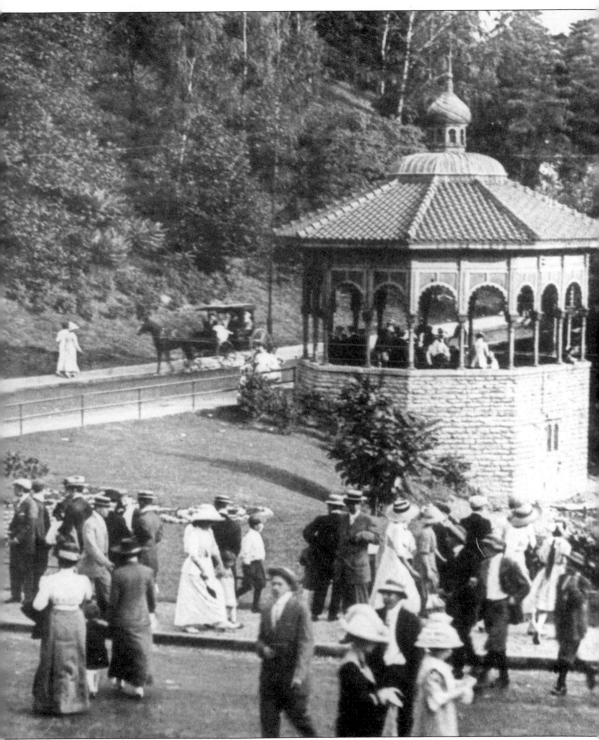

Strauch, superintendent of the board of park commissioners, designed the Eden Park plantings since the land was weedy and barren after the vineyards died. (William H. Deak Collection.)

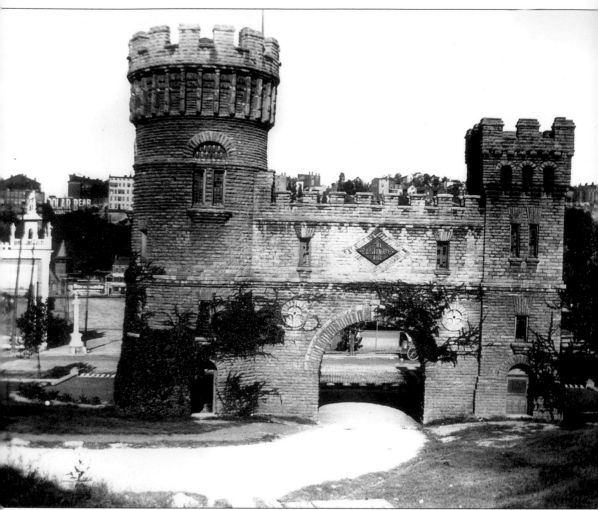

The Elsinore Tower entrance to Eden Park was built to conceal a valve house which controlled the water flow from the Eden Park reservoirs to the city basin. Designed by Hannaford & Sons in 1883, it was based on a stage set for *Hamlet*. A. G. Moore, who was the superintendent of the Cincinnati Water Works, wanted a novel design that would add to the beauty of the park. He was also Samuel Hannaford's brother-in-law. This photograph was taken in 1896.

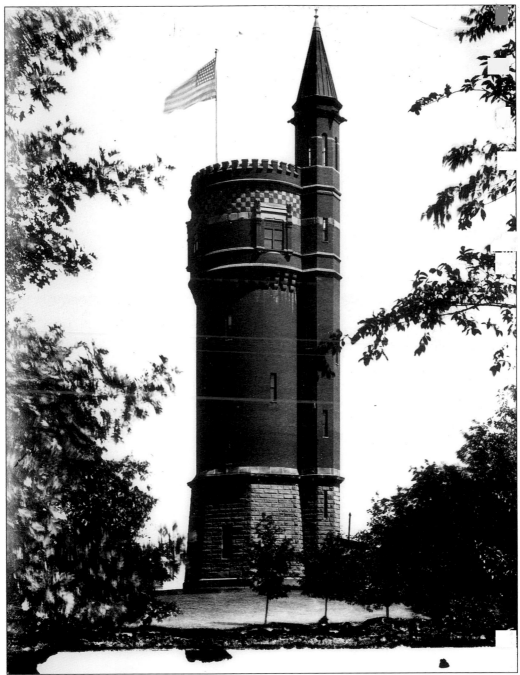

The water tower was designed by Hannaford & Sons to look like a castle keep and was completed in 1894 at a cost of $135,000. For a nickel, park patrons could ride a hand-operated elevator to an observation platform in the turret. The turret is decorated with bewinged gargoyles. There was also a spiral staircase. At the top, the red-brick tower is 997 feet above sea level. It functioned as a pressure tank to get water into Walnut Hills. By 1912, the tower was no longer in use. The copper-sheathed steeple was removed in World War II as a donation to a scrap metal drive. This picture was taken just before the tower's completion on October 9, 1893.

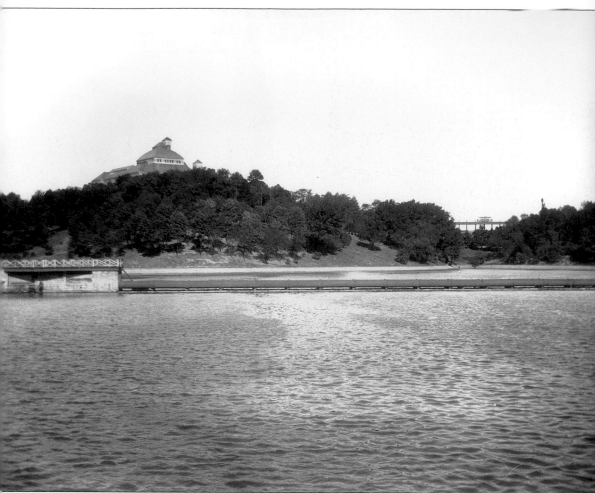

One of the two reservoirs is shown above. In the right background, a street car can be seen on its tracks above the main entrance. The basins covered 12 acres and provided water for the low-lying areas of the city. Construction started in 1866 in an area of the park that had been a limestone quarry. The upper basin was completed in 1874, the lower in 1878. They held 100 million gallons, which was an 8-day supply. The reservoirs acted like huge settling tanks for water pumped from the Ohio River and were drained and cleaned every other year. This was the reason for two basins: one would be in service while the other was being cleaned and repaired.

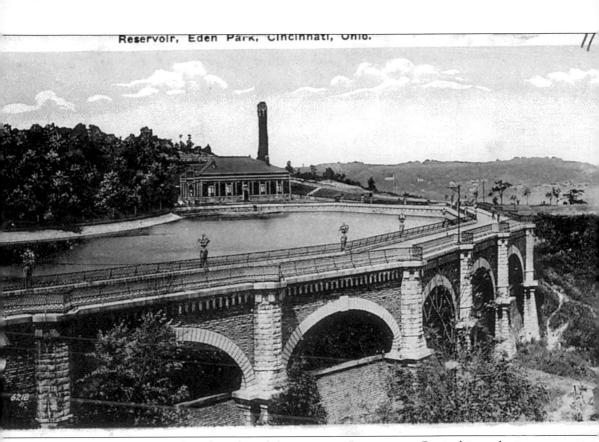

The pumping station stood at the edge of the reservoir. Romanesque Revival in style, it was built in 1889 of red brick. The chimney is decorated with griffins. It once served as the radio station for the Cincinnati Police Department. (Author's Collection.).

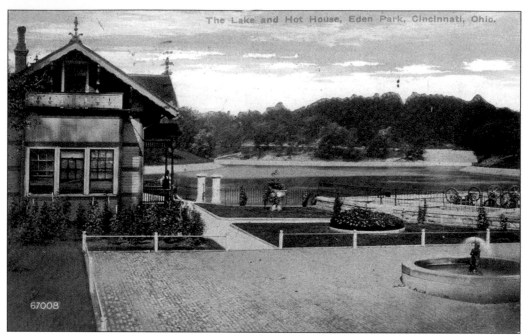

The Krohn Conservatory wasn't built until 1933; however, there were two previous greenhouses which provided plants for viewing and cultivated flowers to plant in Eden Park. This 1911 postcard shows an earlier building that was a hot house in the style of a Swiss cottage. (Author's Collection.)

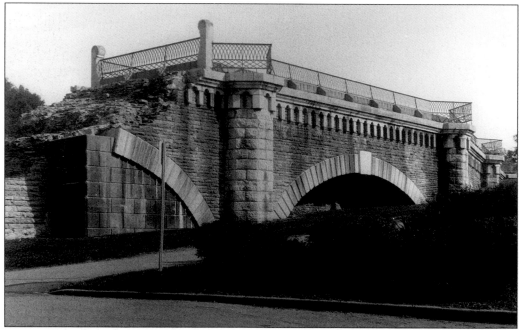

In the 1960s, the lower reservoir was torn down, while the upper had a new tank constructed within the walls of the old one. Mirror Lake is above this reservoir. Here you can see that the old reservoir base was 48 feet thick, tapering to 18 feet at the top. It was filled in to create play areas. (Photograph by William H. Deak.)

Five

HEARTH AND HOME

Although the location is unknown, this is labeled as "Uhlenkotte's log cabin."

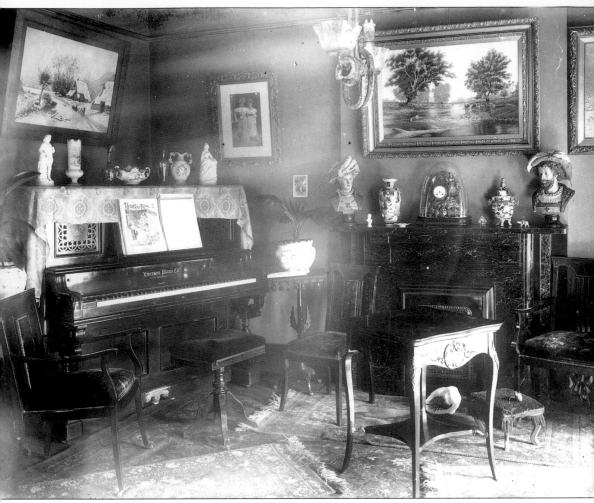

An Emerson piano, manufactured in Boston, Massachusetts, fills one corner of the parlor. Notice the gas light fixture. The piano is decorated with art-painted pottery and the mantel with oriental porcelains. The two pairs of plaster statues provide balance. The sheet music is open to "Hearts Forever." The plain, sturdy furniture was mass produced.

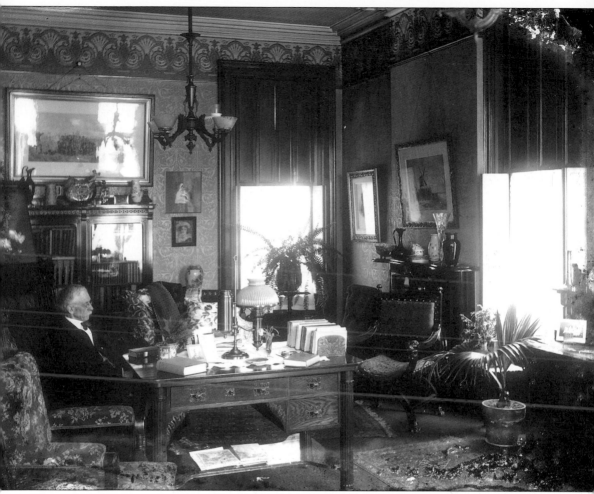

This is the opposite end of the well-appointed room on the cover of this book. The room was long enough to have multiple chandeliers and fireplaces. With a bow-front bookcase and oak desk, this room is full of the "antiques" that are so sought after today.

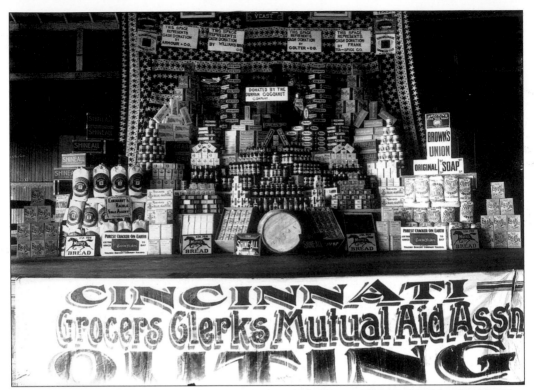

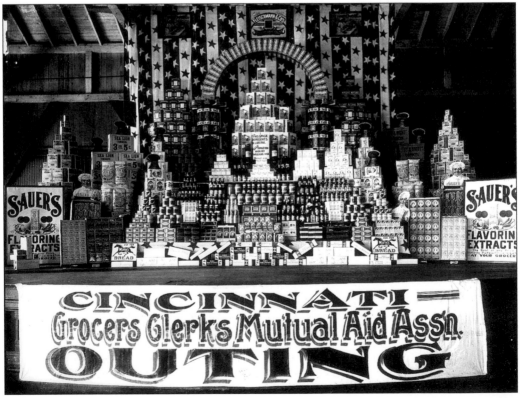

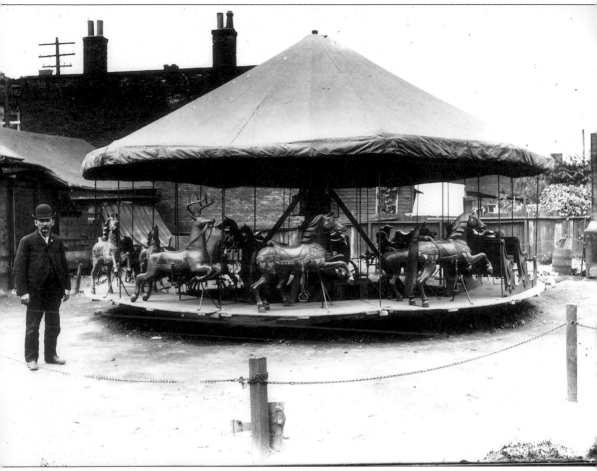

This carousel with hand-carved horses would have been erected for festivals. With a canvas roof and wooden sectioned floor, it could easily be disassembled and moved.

(*opposite*) These displays of the Cincinnati's Grocers Clerks Mutual Aid Association Outing show a profusion of goods available locally. Muth's bread, Shine All scouring soap, Egg 'O See, Toledo Flakes—the Purest Cracker on Earth, Rovers Blue Naphtha, Little B Flour, Brown's Pine Tar Soap, The Celebrated Snow King, and Fleishmann's Compressed Yeast are a few of the products on display. In the second photograph, Sauer's Flavoring Extracts, Sea Lion Tobacco 3 oz 5c, Day & Night 3 ounces, Nut Flakes, Mothers, Cero Fruits, and Fleishmann's Compressed Yeast are showcased.

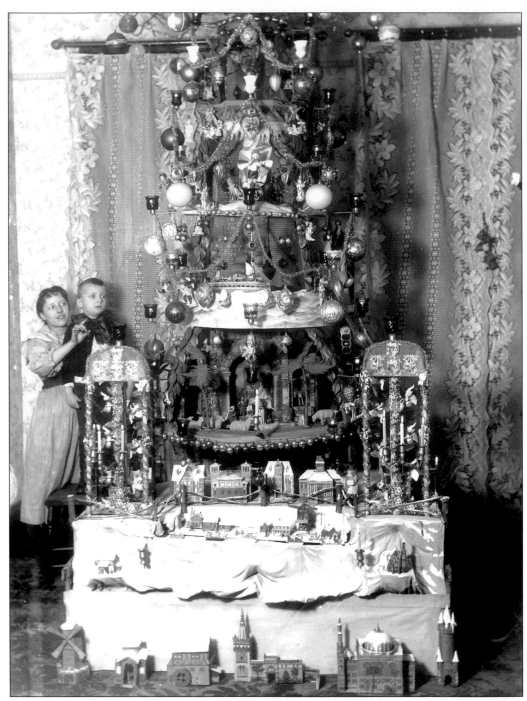

Rather than using a fresh Christmas tree, some German households in the 19th century had ornament-bedecked wooden pyramids. This candle-lit example contains several villages, a manger layer, a ship at sea, and ornaments to the ceiling. Topped with a wire canopy, rather than a star, it provides more space to hang ornaments. During Christmas at the John Hauck House Museum at 812 Dayton Street, a similar structure is displayed. The tree in the photo was in the Schmidt household *c.* 1893.

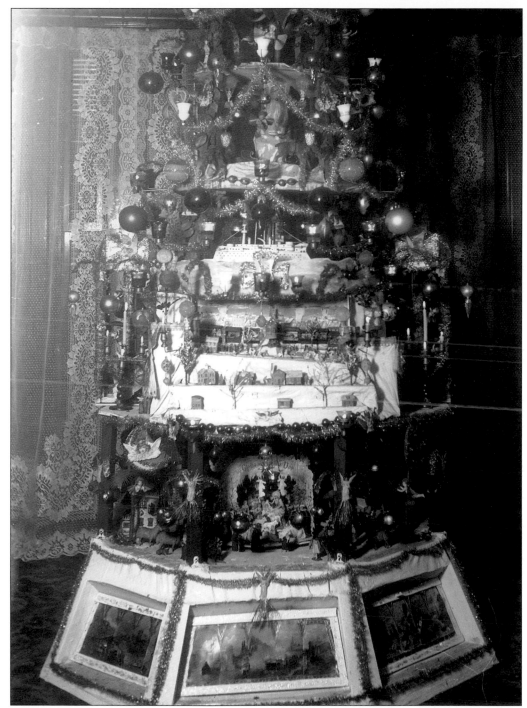

This image provides a close-up view of the manger. Mixed with blown glass ornaments are Victorian scrap ornaments. In addition to candles, votive-style lights glow. The swans, upper front, have spun-glass tails and wings. An explanation of the origins of the Christmas pyramid may be the German *Lichstock*, which was a smaller version of this structure and had the nativity on its shelves, along with candles, evergreen branches, and candy.

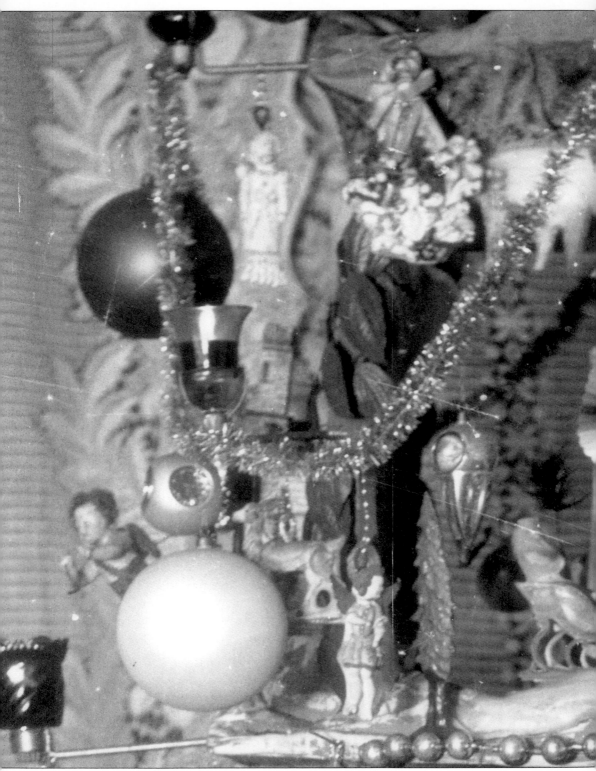

Cherubs ascend on spun-glass wings in the elaborate end display.

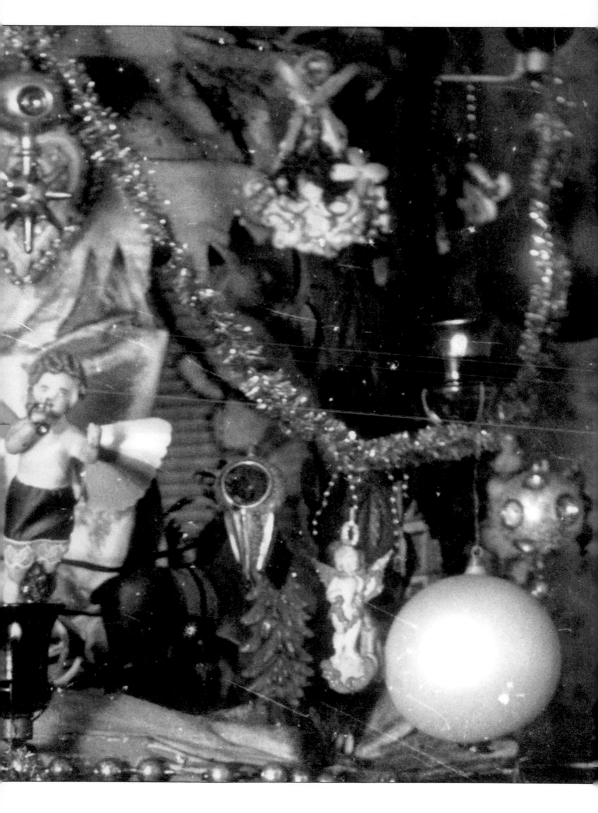

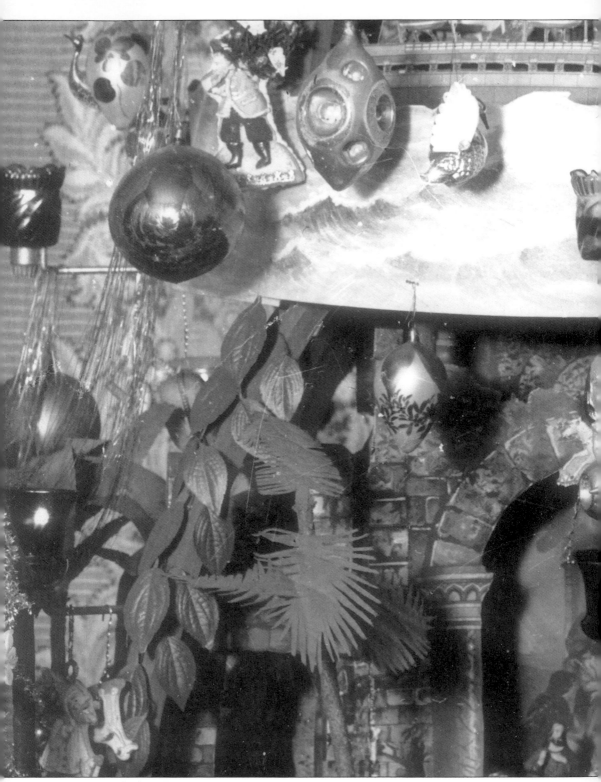

Tinsel garlands the trees.

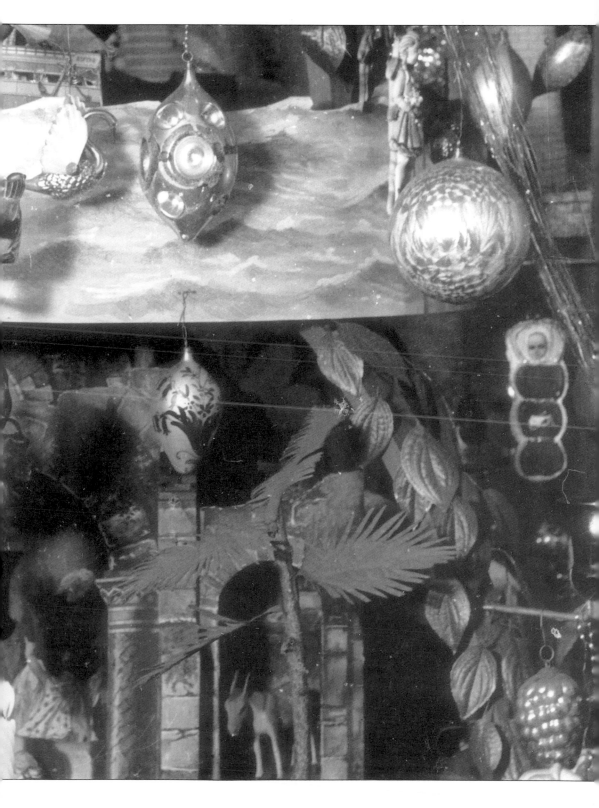

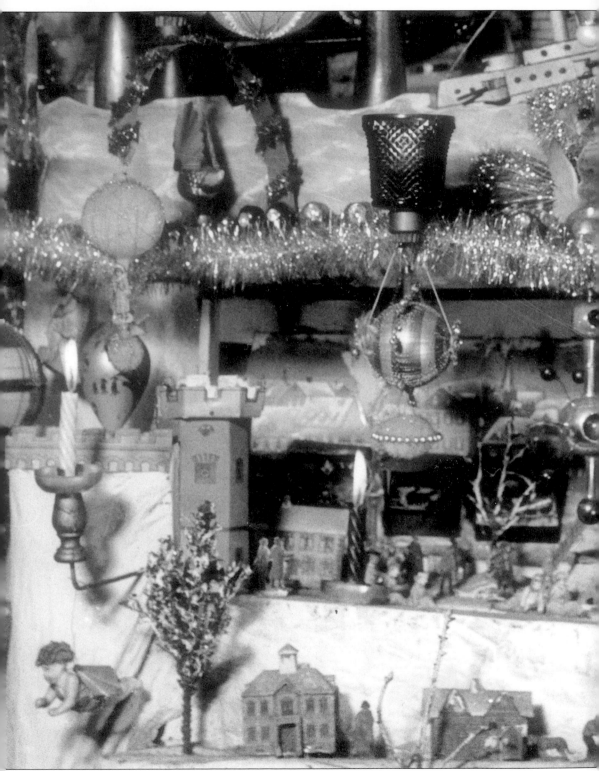

Along the base are painted panels. A tiny village and a battle ship (top) fill the center.

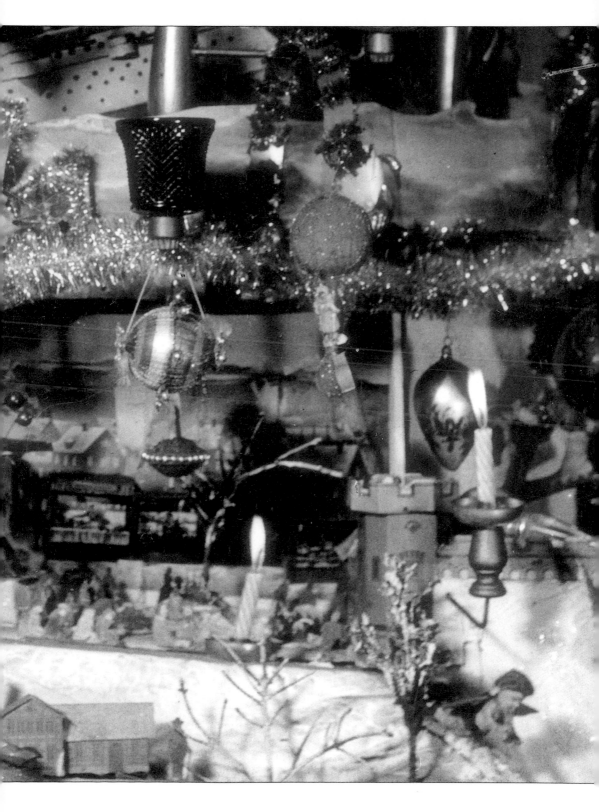

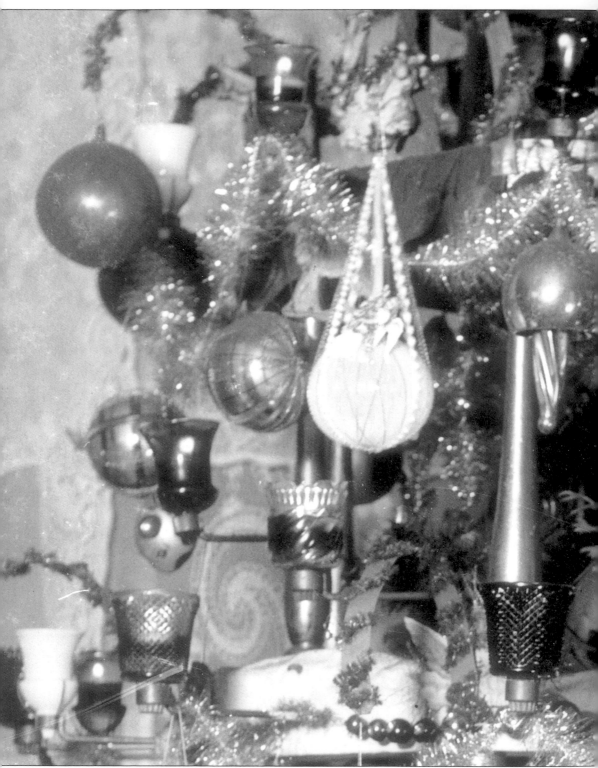

The blown glass ornaments may have been made in the village of Lauscha, Germany.

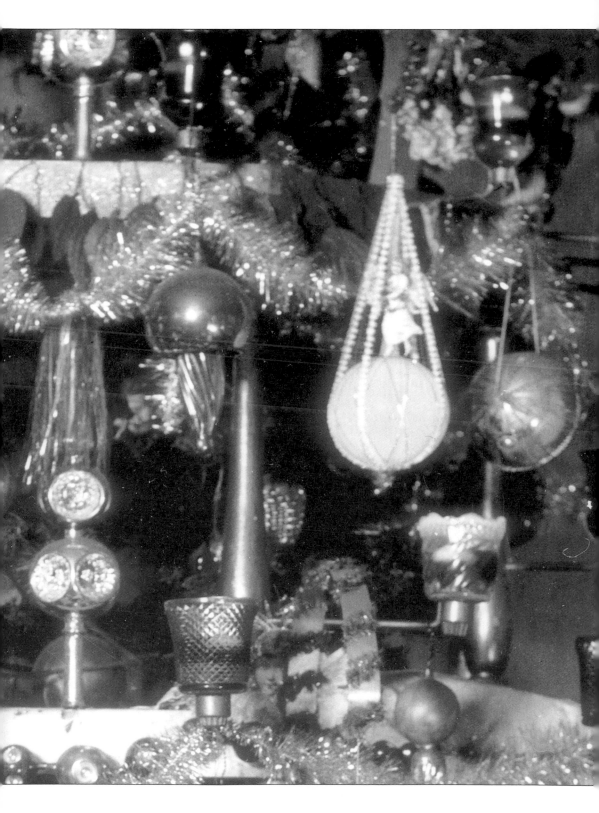

This later Christmas tree boasts electric lights.

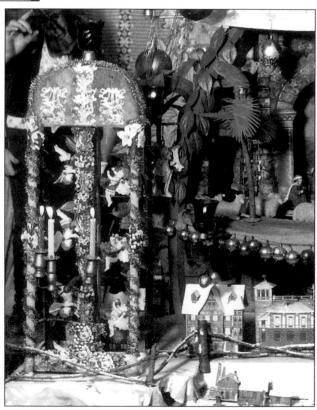

A close-up view shows the cardboard village where tiny figures and animals can be seen.

Six

JUNCTA JUVANT —STRENGTH THROUGH UNION

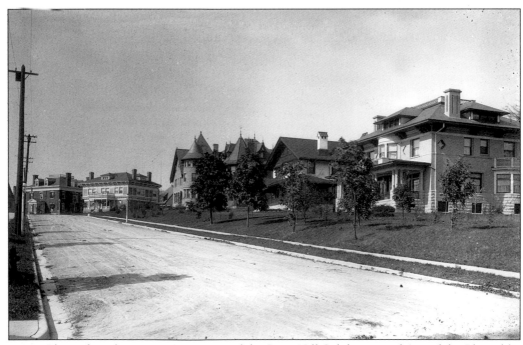

Lenox Place, show here in 1901, is part of the Rose Hill Subdivision of Avondale. Platted by Robert Mitchell, owner of the Mitchell Furniture Company, it was planned to attract the upper-middle class. The streets are winding and the lots large. Mitchell's speculation paid off, and he, Andrew Erkenbrecher, and Samuel Pogue, to name a few, built substantial homes there. This formed the core of affluent North Avondale.

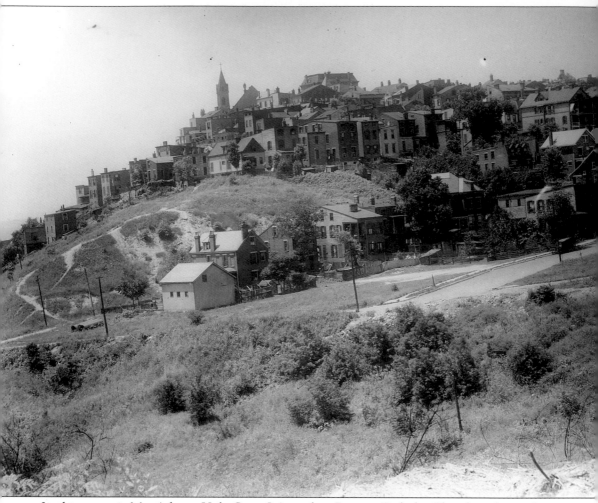

Looking west is Mt. Adams. Holy Cross-Immaculata Roman Catholic Church is shown from the side. Houses thickly cover the hillside. Years of limestone quarrying undermined Mt. Adams, leading to land slides.

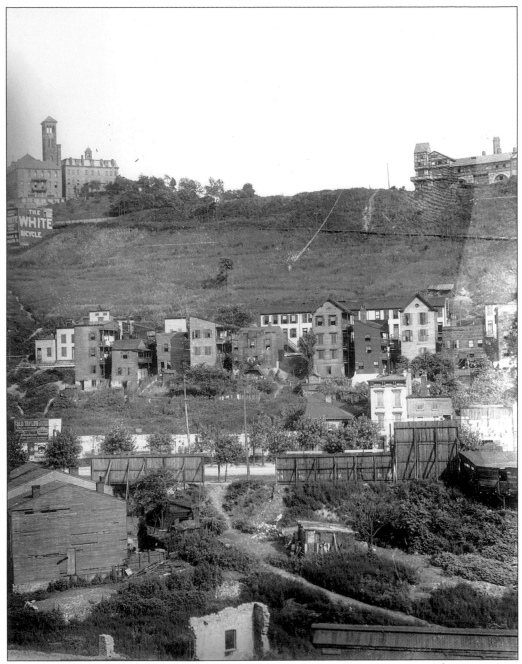

This view was taken looking east towards Mt. Adams. Rookwood Pottery is to the right, while Holy Cross Roman Catholic Church and Monastery is on the left. The monastery was built on the site of the original observatory and is surmounted by a 130-foot-high tower. Before Rookwood Pottery, the location was Pyrotechnic Gardens, where Harian Diehl set off firework displays produced in his next-door fireworks factory. Several explosions and fires led to the closing of Diehl's, and Rookwood Pottery was built on the spot.

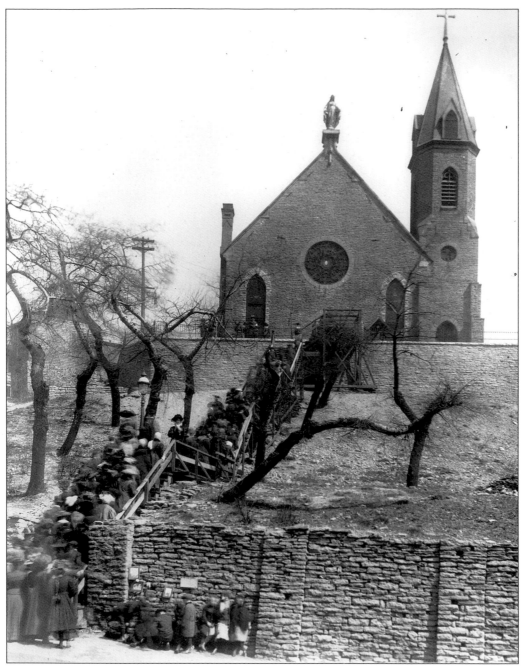

"Praying the steps" on Good Friday up to Holy Cross-Immaculata Roman Catholic Church is a Cincinnati tradition dating from 1861. Built of Mt. Adams limestone on a spot chosen by Archbishop John Purcell, the church is a prominent landmark. The penitent pray a "Hail Mary" on each of the 85 steps and an "Our Father" on the landings. In 1903, the cast-iron statue of the Immaculate Conception was purchased for $1,600. The wooden stairs were replaced in 1911 with concrete. Another local custom is the "stealing" of its statue of St. Patrick by the Ancient Order of Hibernians, who return it following the St. Patrick Day parade. This picture was taken in 1906. The steps may now be crumbling, but lines of the faithful form every Good Friday.

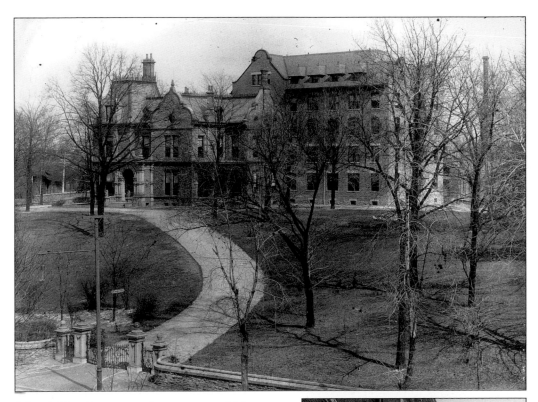

(*above*) The Cincinnati Conservatory of Music building was designed by James W. McLaughlin for Truman B. Handy, a prominent builder, entrepreneur, and stock market speculator. After a short occupancy by Handy, it was purchased by John Shillito, the department store magnate. In 1902, the house was occupied by the Cincinnati Conservatory of Music. It was demolished to build Merry Jr. High School, now Mayerson Academy.

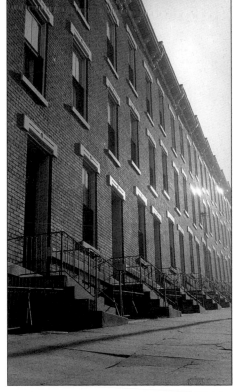

(*right*) The row houses of Glencoe Place have seen many changes. They, and the Glencoe Hotel, were built to spite the affluent property owners on Auburn Avenue. Truman B. Handy wanted to purchase property on Auburn Avenue himself, but no one would sell him land. So he purchased this steep, hilly property and built this row house for German immigrants, although it isn't clear weather Handy or his son-in-law, Jethro Mitchell, did the actual construction. This was part of an area known as "Little Bethlehem." The illuminated cross that once was on Christ Hospital could be seen for miles at night. The light of this cross shining on snow-covered homes clinging to the slopes of Mt. Auburn is the source for the name. (Photograph by William H. Deak.)

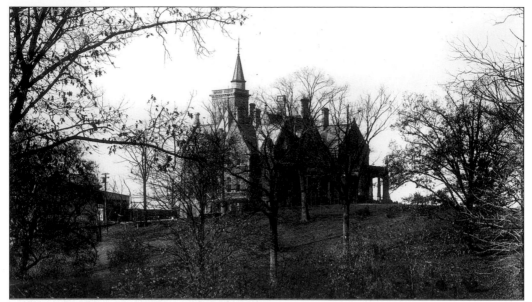

Scarlet Oaks was built for George K. Schoenberger in 1867 on a prominence 200 feet above the valley below. The architect was James Keyes Wilson, who also designed the gateway, office building, and Dexter mausoleum in Spring Grove Cemetery. Schoenberger's grandfather was a Hessian officer who had been captured in the Revolutionary War. He was quartered in (then) Berkely County, Virginia, near the Cumberlands. After the war, he traveled to Pittsburg and worked in the iron business. George came to Cincinnati initially to represent the family in the iron trade. He owned the Juanita Ironworks. Scarlet Oaks' construction brought craftsmen from Europe to carve the woodwork. What is now Inwood Park was Schoenberger's Woods, where he had his summer home. It was on the grounds of Schoenberger's Woods that a limestone quarry operated, providing foundation stone for many of the local homes. Schoenberger was a philanthropist and one of the developers of Spring Grove Cemetery.

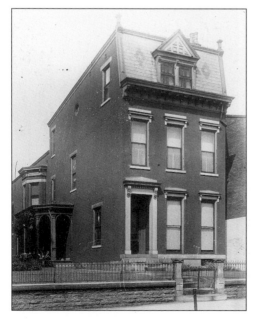

An Italianate-style brick house was typical of many homes in the older sections of the city. One room wide and three or four deep, two stories with large windows, unpretentious, and well-built, these homes are for sale throughout Cincinnati. This homeowner was upper-middle class because of the side porch and yard.

(*right*) St. Leo Roman Catholic Church, Fairmount, was dedicated in 1911. Built in the Romanesque Basilica style, this church has been the heart of this neighborhood's Catholic community for many years. The church merged with St. Bonaventure in 2003, and all of St. Bonaventure's original buildings were demolished in 2004.

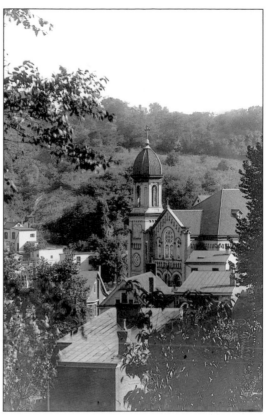

(*below*) St. Rose of Lima School, Eastern Avenue, was in an area called Fulton when it was built. Fulton was named for Robert Fulton, inventor of the steamboat, and was a concentration of boat building businesses. Flooded when the river swells high above flood stage, St. Rose's has a measuring stick painted on the exterior rear of the church marking the flood crests it has survived. In 1937, the flood waters reached almost 80 feet. The church and school are on the National Register of Historic Places, and the church's spire has made it a prominent landmark. The church's architect was Adolph Druiding, who also designed the now demolished St. Bonaventure Church in South Fairmount. St. Rose was born in Lima, Peru, in 1586 and is the patroness of America.

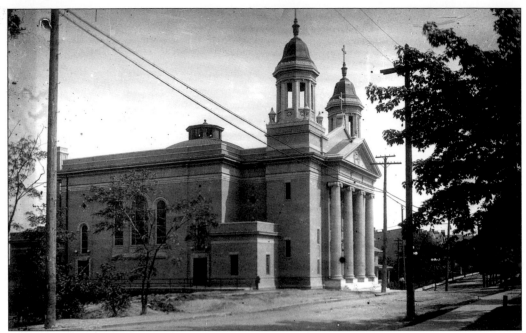

Holy Family Roman Catholic Church in Price Hill was built in a style with Byzantine influence. Price Hill was named for the Welsh immigrant Evans Price who owned a general store and invested his monies in land west of the Mill Creek. His son Reese financed the building of the Price Hill Incline. William, Reese's son, took over the building and management of the incline. Reese was a canny businessman and operated a brickyard and saw mill to encourage people to build upon his family's land.

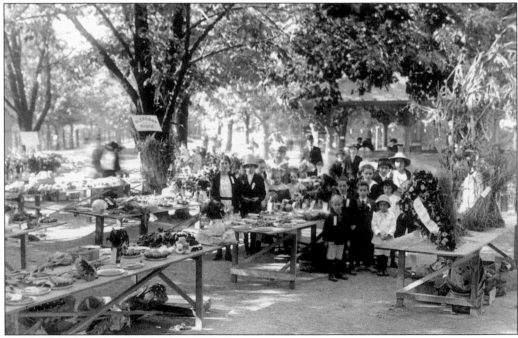

This harvest picnic was held by residents of Pleasant Ridge.

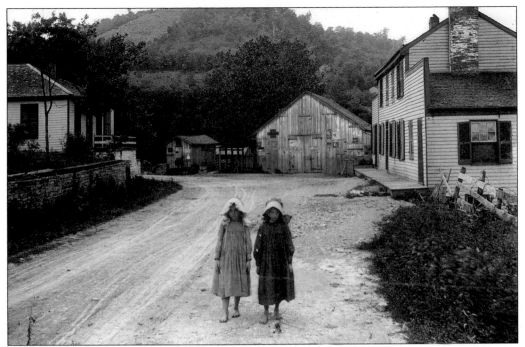

The community of Lick Run/Lick Run Hollow is in Fairmount, where Lick Run Creek runs east to west and is a tributary of the Mill Creek. Queen City Avenue was once named Lick Run. Early settlers followed a trail used by Indians into this valley. It was rich in limestone that settlers used for construction, and the soil grew grapes readily. During the years of prohibition, the seclusion of the valley and the wildness of the terrain made it an ideal place to hide bootlegged liquor; the location was not ignored by George Remus, who owned a farm in an isolated spot there.

This is Lick Run/Queen City Avenue.

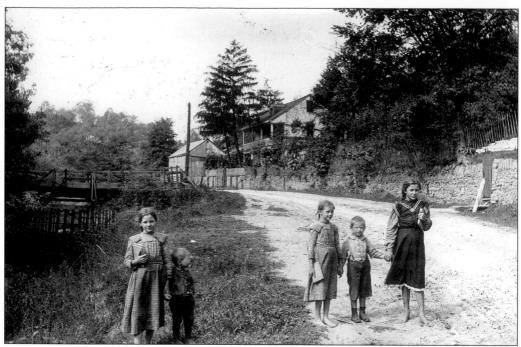

The girl in the black dress is Emma Dresch. The children are carrying textbooks. (Lick Run Avenue.)

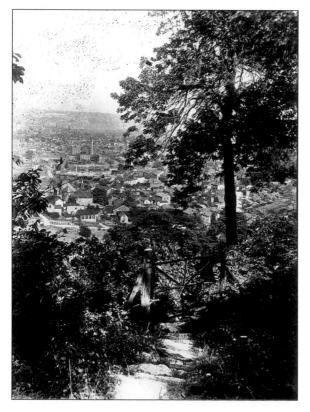

Once a pristine valley teaming with wildlife, the Mill Creek valley was quickly deforested, settled, and farmed. Since it was flat, it became a transportation corridor and was heavily industrialized.

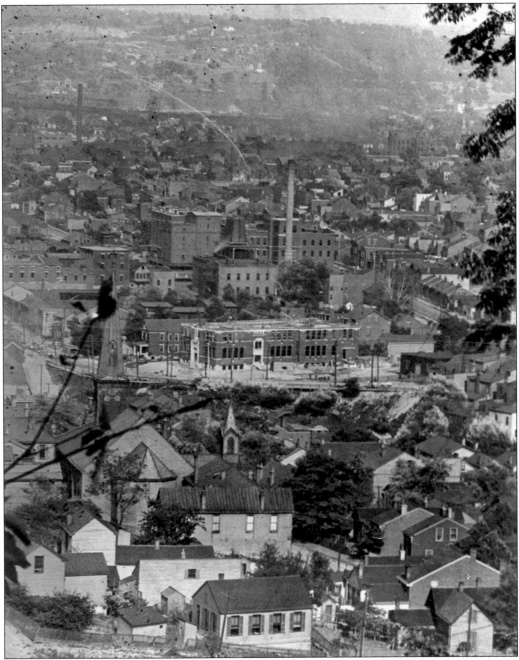

At one time, the Mill Creek valley supplied Cincinnati with vegetables. The heavy forest gave way to meat packing plants, the stock yards, Jergens Soap Co., multi-storied factories, and railroad tracks. By the end of the 19th century, it was the industrial core of Cincinnati.

In the distance is Bald Knob, which was whittled down to provide the fill on which Union Terminal was built.

The rectory of St. Aloysius-on-the-Ohio in Sayler Park (designed by architect E. Schlochtermeyer), was built in 1898 and razed in 1923 so that a new bell tower could be constructed. The church itself was newly built and dedicated in 1888.

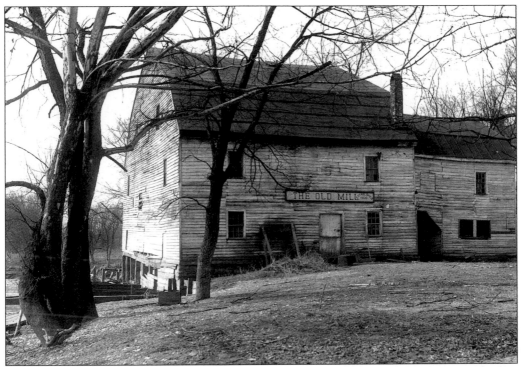

William J. Hartman's Flour Mill, established in 1800, was on Wooster Pike in Plainville, one mile east of Newtown Bridge. The dam provided power to turn the mill. Notice the canoes in the foreground. Looks like a good fishing spot on a hot summer's day.

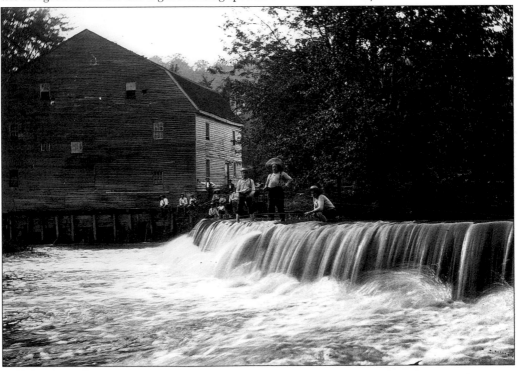

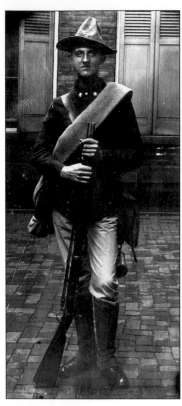

Robert Schmidt is pictured here in his Spanish American War uniform.

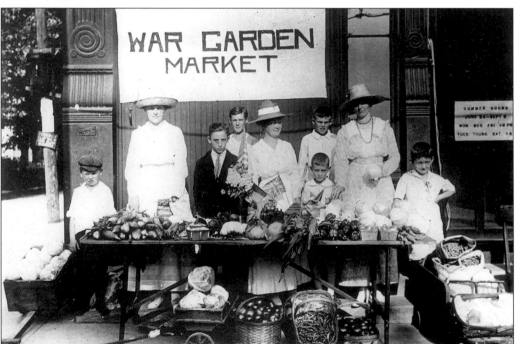

During World War I, citizens were encouraged to plant "War Market Gardens." Here a group in Madisonville displays their produce for sale.

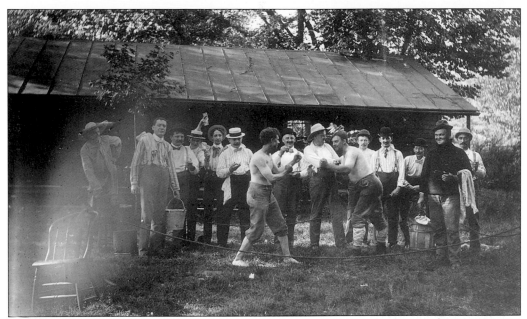

Bare-knuckle boxing was a sport made popular by John Lawrence Sullivan (1858–1918). In this picture, each man has a "trainer" in the corner with a bucket, while a man in back waves his bet. *(below)* The referee calls the lighter of the two men out. Pugilism was illegal because it had few rules and could include biting and gouging. There were no limits to the number of rounds. Sullivan secured his reputation in 1889 with a 75-round match against Jake Kilrain. However, when using gloves, Sullivan lost in 1892 to "Gentleman Jim" Corbett. It wasn't until New York legalized and regulated boxing in 1896 that other states did also. Sullivan retired in 1896 with his bare-knuckle title intact. Sullivan was much admired and copied because of his flamboyant personality. Boxing was included in the 1904 Olympics and was used to train World War I soldiers.

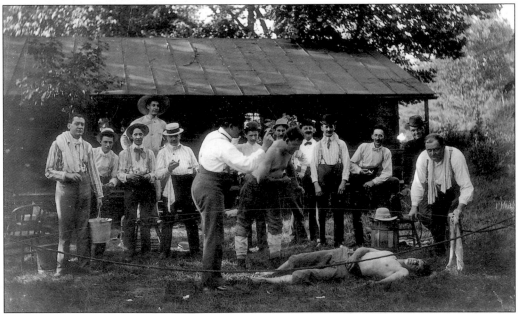

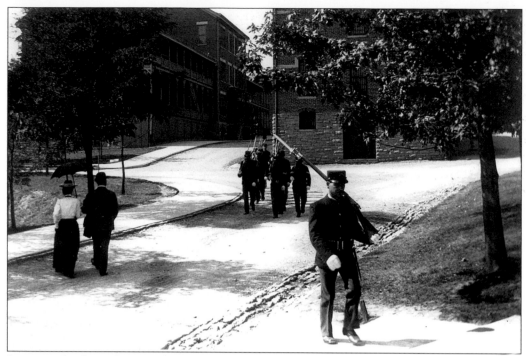

Between the barracks at Ft. Thomas, soldiers march to their next assignment. Ft. Thomas, Kentucky, was named for Gen. George H. Thomas, who fought in the Civil War. The 6th Infantry Unit stationed there was sent to Cuba in the Spanish American War. The base also served as a convalescent hospital during that war. It was active in sending troops to both World Wars.

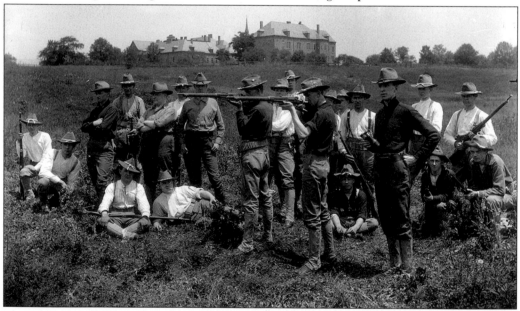

The Ohio National Guard in Hartwell is shown here prior to 1903. The guns are Krag rifles, a variation of the Swedish Krag-Jorgenson rifle. The Krag was used starting in 1890. It was .30-caliber and had an unusual magazine that opened from the side. In 1903, the Springfield rifle became the primary weapon. It was adapted from the German Mauser.

Ed Bingle was one of the many young men who delivered or sold the daily newspapers. (William H. Deak Collection.)

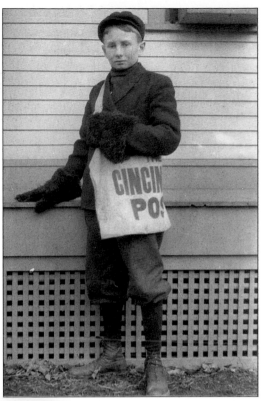

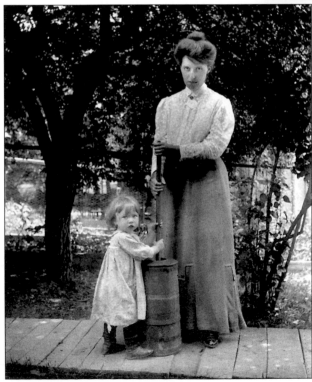

A little helper assists with the butter churning.

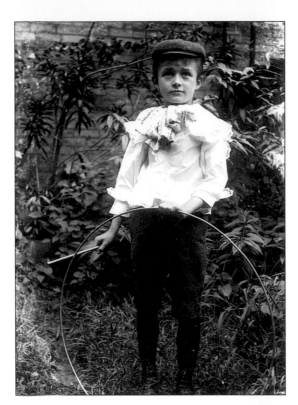

Years before the hula hoop, the hoop and stick were popular.

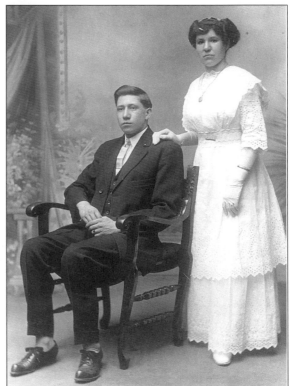

John A. Hubert and Margaret Dipong were married in 1913 in St. Augustine Catholic Church, Over-the-Rhine. This is their wedding picture. Her dress is of eyelet lace, and she wore her rings over her gloves. (Author's Collection.)

Seven

THE DUVENECK YEARS

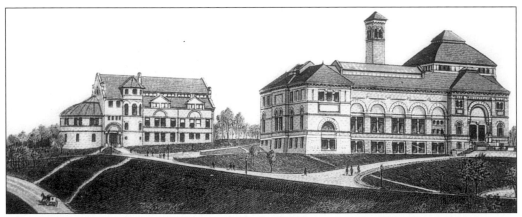

This drawing shows the original design of both the Cincinnati Art Museum and Cincinnati Art Academy, designed by James W. McLaughlin. When the art academy was founded in 1887, artists and teachers were attracted to and resided on Mt. Adams. The lack of roads and steep climbs made residency and access to studio and classes an attractive alternative to a daily trek from other parts of the city. (William H. Deak Collection.)

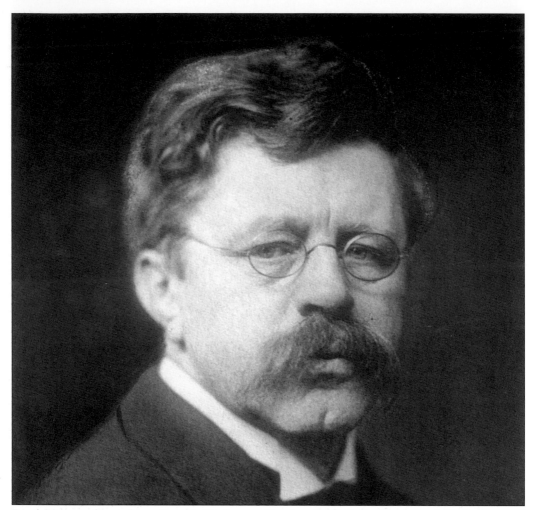

Frank Duveneck was born Francis Decker on October 9, 1848, in Covington, Kentucky, and was named for his father's brother. Frank's parents, Bernard Decker and Catherine Siemers, originally came from Westphalia, Germany. Bernard was a cobbler and studied law at night. When his son was 17 days old, Bernard died in the cholera epidemic of 1849. Catherine met Joseph Duveneck, and they married in 1850. They had a family of 11 children, and Frank didn't learn that he was not Joseph's son until he was an adult. "Squire Joseph" had purchased property at Thirteenth and Greenup Streets, Covington, for a grocery store. He later produced ale and opened a German beer garden at that location. Frank's mother encouraged him to be an artist and he was apprenticed at age 12 to the Altar Building Stock Co. Under the eyes of Johann Schmidt, Cosmas Wolf, and Wilhelm Lamprecht, he learned painting, gilding, carving, and fresco. They decorated St. Joseph Church (razed—Covington, Kentucky) among others, and Frank traveled with Schmidt for four years to decorate various churches. When he was 21, through the help of Schmidt and Wolf, who recognized his talent and potential, he went to Munich, Germany, to study painting at the Royal Academy. In 1872, he exhibited and sold five of his paintings in Boston, which established him as a painter. He returned to Europe and established his own school in Florence, Italy. It was there that he met another artist, Elizabeth Boott, whom he married in 1886. They had a son, and she died of pneumonia in 1888. Duveneck returned to his parents' home on Greenup Street and became director of the art academy until his death January 3, 1919.

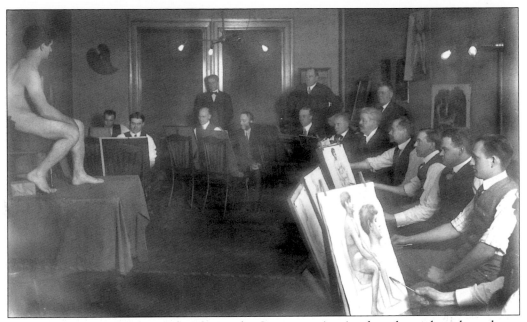

Sketching from a live subject, this class at the Cincinnati Art Academy has only male students. Duveneck is center right among the students. He joined the faculty of the art academy in 1900. The Cincinnati Art Museum has a large collection of Duveneck's sketches and paintings. Duveneck's house at 1232 Greenup Street is undergoing restoration.

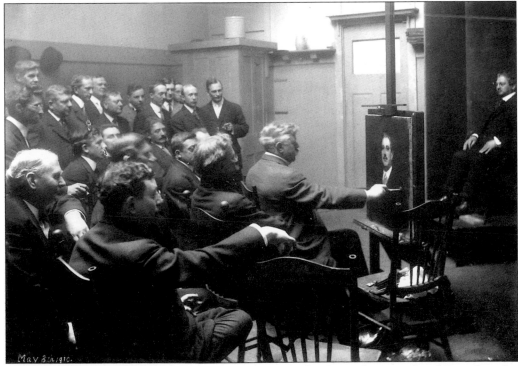

This observation was held May 8, 1910. Duveneck had a devoted group of students whom he called "his family." After school, they would retire to a nearby tavern for food and discussion.

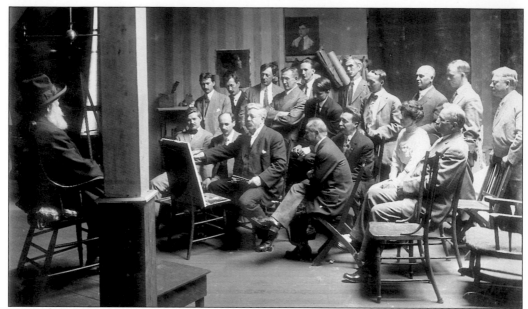

Duveneck used to admonish: "Remember, great artists use few colors; amateurs use many." This meeting was held on May 18, 1913.

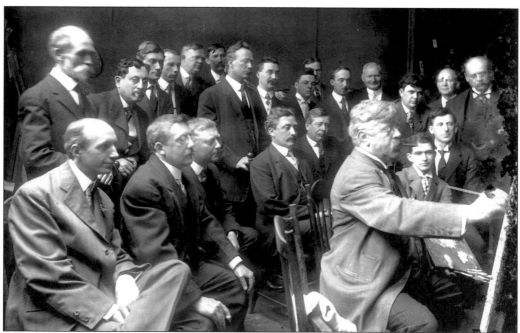

Duveneck demonstrates portrait painting to the Cincinnati Art Club, May 16, 1909. He divided his time between teaching and being an advisor to the Cincinnati Art Museum. At the end of each meeting of the Cincinnati Art Club where he would critique their work, Duveneck would paint a portrait they could auction to raise funds. The club is the second-oldest organization of its type in the country. Duveneck is buried in Mother of God Cemetery, Covington, by the grave of his mentor and friend Johann Schmidt (1825–1898). Club members still go to Duveneck's grave in an annual pilgrimage on Memorial Day.

Duveneck's summer house was in Kentucky. He also went to Gloucester during his summers to paint, because his son was being raised by his wife's family there.

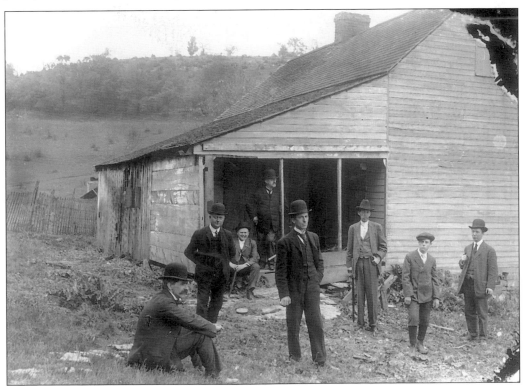

Friends gather at the summer house. Duveneck is standing in the doorway.

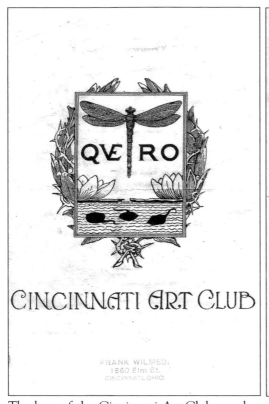

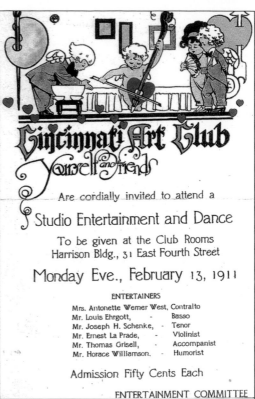

The logo of the Cincinnati Art Club was drawn by Henry Farny in 1894. "Quero" means "we seek." The dragonfly is an allegory of the artist; arising from simple beginnings, the larvae struggle and emerge from the pond to take flight on beautiful wings. The Cincinnati Art Club was founded in 1890. Frank Wilmes was secretary for many years. (William H. Deak Collection.)